Yellowstone Country

Yellowstone Country

The Photographs of Jack Richard

MARK BAGNE

AND

BOB RICHARD

Roberts Rinehart Publishers

In cooperation with the Buffalo Bill Historical Center

Roberts Rinehart Publishers

A Member of the Rowman & Littlefield Publishing Group
4720 Boston Way
Lanham, MD 20706

Distributed by National Book Network

Library of Congress Control Number: 2002103573

ISBN 1-57098-423-9 (cloth: alk. paper)

Printed in the United States of America

♾™The paper used in this publication meets the minimum requirements of American National Standard
for Information Sciences—Permanence of Paper for Printed Library Materials, ANSI/NISO Z39.48–1992.

This book is dedicated to the Yellowstone Country
and all of her people who inspired
Jack Richard's photography.

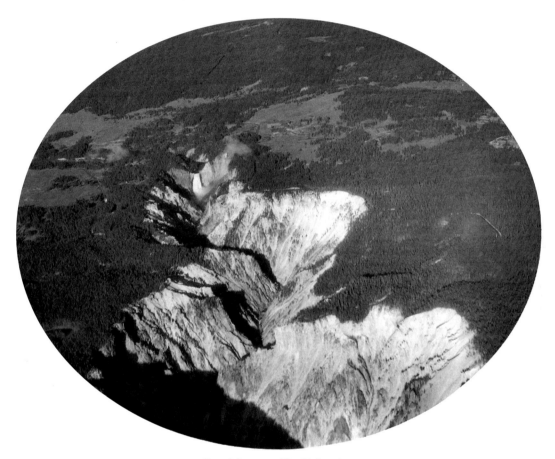

Grand Canyon of the Yellowstone

Contents

Jack Richard with one of his Hasselblads in 1985 at age 76. (photo by Craig Satterlee)

Foreword

What a treat and a real privilege to introduce you to *Yellowstone Country: The Photographs of Jack Richard*. My life is much richer for having known Jack. His remarkable professional career in photojournalism began the very year I began life—right here in my old hometown of Cody, Wyoming. It seems fair then to say that I was "raised up" with a magical, complete exposure to the man and his talents.

Jack had an unerring and uncanny ability to capture the very essence of his chosen subject—equally adept at portraying humankind, bovine, equine, flora, fauna or the spectacular wildlife, mountains, forests and prairies of his native Park County and Northwestern Wyoming. His creative eye and his insightful sense of his subject matter, combined with its significance in the evolving history of our West, are quintessential Jack Richard. For his career of more than half a century, Jack's catalog of events results in this dazzling and moving collection—a most representative array—but yet only a fraction of his finest works.

Jack Richard and his family have been friends of my entire lifetime. He recorded our marriage, Brother Pete and Lynne's wedding, family gatherings, dear Mom and Dad at all stages of their lives— actually, he was our family chronicler! These pages will give the reader a wonderful sense of Jack Richard—the man, the artist, the citizen-patriot, the lover of nature—the wise, wry, witty man—a dedicated historian who meticulously recorded his legacy on film, to be shared with future generations. He could have practiced his craft anywhere in the world—but he chose the Cody Country. He loved it, and he loved its people.

So let your imagination carry you along, as your senses feel the rich tapestry woven by Jack's incredible talent with camera, lens, film and the perfect "creative sense" of capturing the moment in photographic prose. I know you too will treasure this collection.

Enjoy!

Alan K. Simpson, United States Senator (Wyoming) Ret.
Chairman, Board of Trustees, Buffalo Bill Memorial Association

Dr. Harold McCracken was the first director of the Buffalo Bill Historical Center. (1960)

Preface

This book is a much-needed retrospective of the images of Jack Richard, one of the finest photographers of the Yellowstone country of Wyoming and Montana. Based in Cody, Wyoming, Jack Richard ran a local photographic studio and published a newspaper, *The Cody Times,* that eventually merged with *The Cody Enterprise*. As such his studio collection of photographic images covers a tremendous range of topics and styles of photography. Controlled studio portraits certainly document the residents of Cody, yet they also occasionally capture an intangible yet powerful Western Spirit in weathered faces and proud postures. A regional pioneer of photojournalism, Richard took full advantage of the camera to tell a story and attract reader interest. His lens recorded life in the nearby Heart Mountain Japanese-American relocation camp during World War II, scientific excavations at the Mummy Cave archaeological site, and a variety of Cody lifeways and businesses. Yellowstone National Park and Shoshone National Forest are ever-present themes in his work, and his love of wilderness and the American West shines brilliantly in these images. Yet Richard's photography, as shown herein, went beyond mastery of documentation and reporting to grasp the essence of the arts—the creation of visions that touch peoples' emotions and excite the imagination. And Visions we see—from the grandeur of Yellowstone landscapes to the beauty

Richard photographing Gertrude Vanderbilt Whitney's "Buffalo Bill—The Scout."

of modern industry, from the hint of history in the gleam of an old trapper's eye to the pride of a small western town in its progress and future promise.

The McCracken Research Library of the Buffalo Bill Historical Center is proud to hold the studio collection of Jack Richard. This selection from his best works can now be shared with all who maintain an active interest in the art of the photograph and the culture of the Yellowstone Country of the Rocky Mountain west.

Nathan E. Bender, Housel Curator
McCracken Research Library
Buffalo Bill Historical Center, Cody, Wyoming

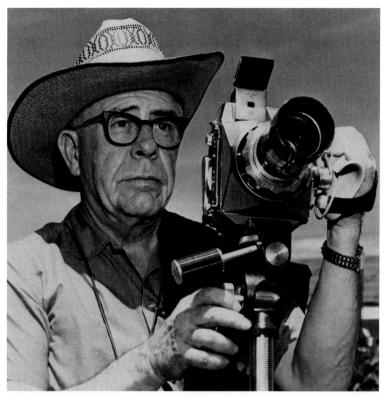

Jack Richard takes photos on Yellowstone Lake. (1970s)

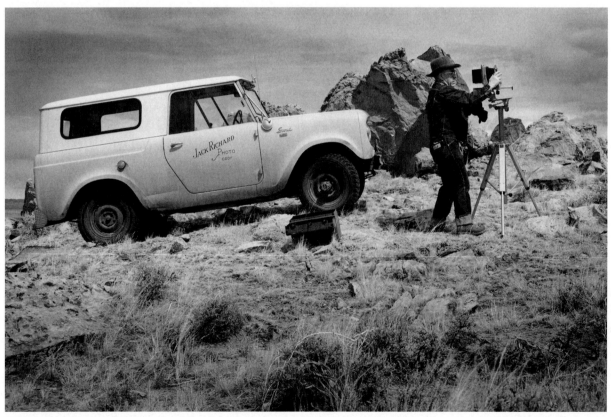

Richard at work in the field with his International Harvester Scout. (1964)

Introduction

This book is for everyone who loves pictures. On every page a picture shines like a gem polished over the course of a three-year production. The picture lovers who conducted this search hope everyone who turns these pages feels the thrill we felt each time we opened another box of prints on our search for 140 selections representing "The Best of Jack Richard."

It was like a treasure hunt through the Jack Richard Collection of 4,000 prints and 160,000 negatives in the archives of the McCracken Research Library of the Buffalo Bill Historical Center in Cody, Wyoming. Richard donated his collection in 1989, and the Historical Center has preserved it ever since in its cool library vaults. In raising them from storage, we hope to lift these images, and the spirit behind them, into the light for a fresh look.

For people who live in Yellowstone Country, this first collection of Richard photos in book form will spark memories of pictures they saw in newspapers forty or fifty years ago and still see enlarged on the walls of the courthouse and town hall. For critics and historians from outside the region, this presentation of the photos of Jack Richard (1909-1992) may be viewed as a "discovery" of significant works by a largely unheralded contemporary of Ansel Adams who was closely influenced by "Famous Cowboy Photographer" Charles Belden.

To make our selections, we focused on the heart of Richard's black-and-white photos from the late 1940s through the 1970s and organized nine themes representing the variety and volume of his work. Alongside the pictures, we've tucked in a biography containing surprises even for those who knew Richard best. To present his life and works as he saw them, we tried as much as we could to use his own language he left behind in captions and articles.

We hope to present Jack Richard the way he was known by his son Bob Richard, by his friend Peter Wilson, and by so many people associated with him across Yellowstone Country. Especially for Bob, this project has inspired a rediscovery of his father's photos, his character, and the wonderful influences on his life dating to his upbringing on a guest ranch pioneered by Fred and Margaret Richard. All of these influences, and many people we'll thank in our closing pages, ultimately inspired this "overdue" production.

These influences, embodied in the quality of life, community relationships and spirit of Yellowstone Country's history and pioneers, will unfold in these pages the same way Bob experienced them working side by side with his father on the ranch, at the newspaper, on photo assignments and pack trips, as a ranger in Yellowstone Park, flying in airplanes and working late into the night dodging and cropping photos in the darkroom.

Throughout our work as photo editors, photo technicians, researchers and writers, we had the feeling Jack was looking over our shoulder with the same precision he demanded as a newspaper editor reviewing pages before they go to press. We can only hope he would give this edition a thumbs-up and authorize us to "ship it."

— Bob Richard and Mark Bagne
— Co-authors, "Yellowstone Country: the Photographs of Jack Richard"

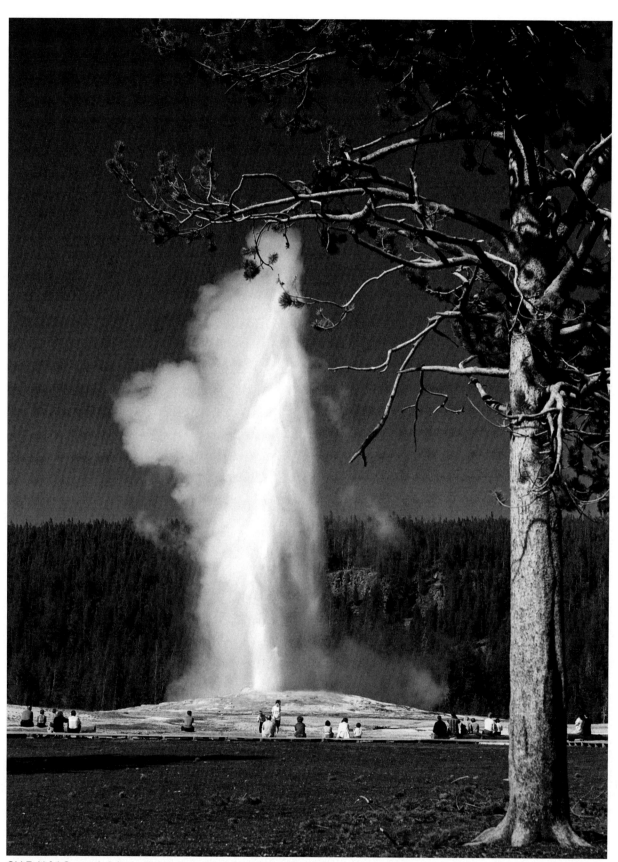
Old Faithful Geyser is "always the charmer," drawing a crowd every time it erupts. (1966)

1.
The Romance of Yellowstone

Above the painted pines are peaks,
Below the shady boughs are creeks.
Across its deep-grown fields and parks
Live deer and elk and quail and larks.
—Jack Richard, 1932

Jack Richard the photographer, explorer and adventurer was topping the ridge along a knife-edge trail, trusting the careful feet of his mountain horse as he cast his gaze across the wondrous world he knew as Wonderland. Toward all points of the compass, for a hundred miles without interruption, majestic peaks rose high above the timbered slopes and grassy valleys. Even the sky above was perfection, truly a masterful creation of warm sunshine, deep blue, and weightless, drifting cotton clouds. His was a lucky lot. With a saddle horse, two pack horses and a light camp outfit, every bit of the 3,240 square miles of Yellowstone Park was his to enjoy. He was steeping himself, body and soul, in the romance of the Yellowstone.

As he rested that evening in the mouth of his tent, he propped his back against his saddle, cocked his feet on the woodpile and listened to the waves of Yellowstone Lake running and murmuring along the shoreline. The intermittent chime of horse bells rang from his horses at the edge of the pines like music to his ears. In the merging shades of the setting sun, "the air grew cool and the fragrance of a thousand wildflowers settled like sweet, refreshing mist born of nature and being returned to it."

As if his photos weren't enough to portray his feelings for Yellowstone Park, Richard left behind words like these to describe a special corner of what was for him a spacious back yard—the mountains and plains, the valleys, lakes and streams of Yellowstone Country. In his early sixties, fresh from an expedition to photograph and record audio of bull elk in the rut, Richard permitted himself "a bit of nostalgia" as he noted Yellowstone's first century as a national park.

"I have known it intimately nearly sixty of its one hundred years, and I have learned to love it in

its every mood and each of the four seasons of the year," he wrote. "It is a marvelous land!"

For Richard, Yellowstone was at once timeless and changing, varying by her seasons and moods from lovely, lovable, and delightful in the spring and summer to exciting and unpredictable in the harsh winter when the "lovely lady" exhibited her gorgeous best and terrifying worst. He came to know Yellowstone by all of her seasons and moods because he scouted and photographed her for most of his 82-year life, not as a passing visitor but as a persistent trailblazer—guiding horseback expeditions, forging through blizzards in rough-and-tumble over-snow machines and soaring above her clouds and peaks as an airplane pilot with a perspective stretching as far and wide as the mountain ranges of Idaho and Utah.

Like all of Mother Nature, which he addresses with reverence and awe, Richard believed Yellowstone should never be isolated from humans but should be preserved for his children and grandchildren to see, study and enjoy. Yellowstone harbors magnificent native animals, he notes, yet she also brings joy, excitement and peace to those others—the two-legged kind.

"She has not been unmindful of her special guests, those that come from the lowlands, cities and farms," Richard wrote in 1971. "Newcomers, she calls them, but of all her children she enjoys them the most for they do not take her for granted, but stop and look and wonder and thank her."

Richard's photos of Yellowstone Park, and his entire portfolio of Yellowstone Country, its landscapes and Western way of life, portray the unchanging beauty of nature alongside the ever-changing actions and influences of man. While picturing the Lower Falls, the ritual of Old Faithful, or a snow-capped mountain mirrored in a high-country lake, Richard also trained his eye on the tourists who motored through the park on those "tiny ribbons of smooth oiled highways." He saw an image worth recording in a father and son spotting a grizzly through a set of neck-strapped binoculars or a couple progressing down a lonesome wood-planked walkway toward a geyser plume.

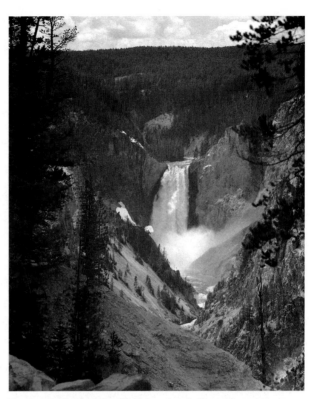

The Lower Falls gush with high water during early spring.

Richard presents an historic and nostalgic glimpse into the Yellowstone Park of the 1950s and '60s—when tourists fed cookies to bears through car windows, park rangers patrolled campsites on horseback and visitors ventured for the first time into the "Winter Wonderland" in hump-backed over-snow contraptions called Bombardiers. Focusing his lens on passing images he knew would become the history of his time, the journalist in Richard quietly recorded the Yellowstone he had known and loved since youth.

Richard, the son of Cody pioneers Fred and Margaret Richard, grew up on the Frost and Richard Ranch—a guest ranch along the North Fork of the Shoshone River, less than 25 miles from the East Entrance to Yellowstone Park. His father and his uncle, Ned Frost, guided some of the first horseback tours into Yellowstone and outfitted many of Buffalo Bill's hunts in the Absaroka wilderness. Steeped and trained in this legacy as a horseman and outfitter, Richard spent many summers in his late teens and early 20s guiding pack trips through Yellowstone Country with younger brother Bob and lifelong friend Peter Wilson.

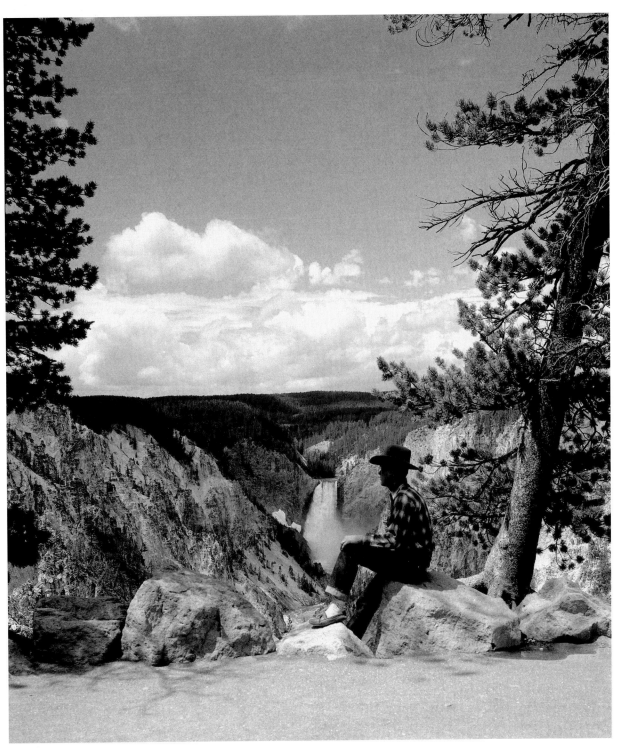

A visitor scans the Grand Canyon of the Yellowstone from Artist Point. (1956)

As the "elder statesman" of these horseback tours, Richard would take the lead, guiding 15-20 guests for two days through the cliff-lined Wapiti Valley and into Yellowstone for a week of adventurous trail rides and campouts on a loop from Fishing Bridge and Canyon to Old Faithful. Wilson hauled up gear in his Model A Ford touring car or a pickup truck and helped the cook and wrangler prepare camp while Richard was guiding and entertaining the dudes, often telling stories he had absorbed from his father or brewed from his own experiences as a hunter, fisherman and cowboy.

Sticking to the backcountry, armed with slingshots to ward off occasional bears, they encountered few people. They could walk right up to the mouths of geysers and had their pick of pretty lakes as campsites. A pack trip through Yellowstone in those days, 1928–35, afforded a "more personal" experience of the park, Wilson recalls. In later years Richard would remember those youthful trips as a privilege savored by a scant minority of Yellowstone's droves of tourists.

"How many of that great crowd knew the fun of sleeping night after night out in the open, under a cloudless, star-lit sky, listening to the quiet laughter of waves on the shorelines, broken only by the far-off cry of a coyote?"

As the years went on, Richard explored Yellowstone by every imaginable conveyance, making his living by doing what he loved, and pressing every chance he had to roll work and play into an outdoors expedition. As a newspaperman and freelancer, he developed trusting associations with park superintendents and rangers who accommodated some of his trips. Among the trips he used to develop photo/story packages were four "winter-time probes into the heart of Yellowstone."

When Richard made his first winter trip in 1955, backcountry travel was restricted to park rangers who tended to "winter keepers" at isolated hotels and lodges and conducted surveys of wild animals, thermal activity and snow depths. Since few people had ever seen the backcountry cloaked in snow and ice, they were excited by the series of accounts he called "Yellowstone in Ermine." In contrast to the spring and summer, he writes, winter is a season

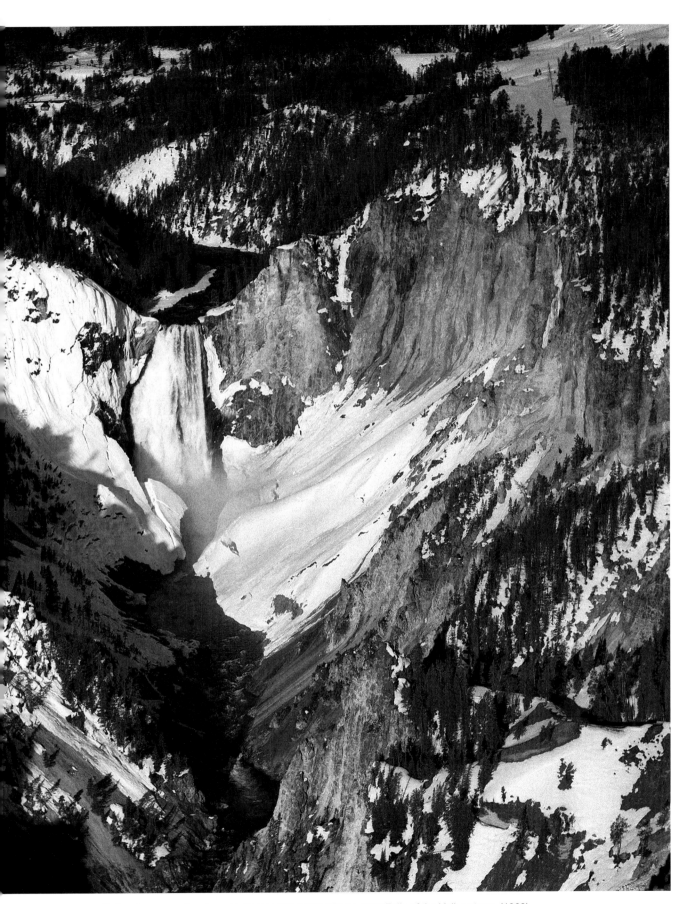

Collapsing snow signals springtime in this aerial of the Lower Falls of the Yellowstone. (1963)

when the trees and hilltops, the ice-silenced creeks and muffled waterfalls are cloaked in beautiful white, when the snows pile up to the very edge of the warm streams tumbling down through the rocks, and steam rising from hot pools condenses and settles on pine trees in thousands upon thousands of diamond-like crystals, making them appear like "castles for little elves."

His search for scenic treasures was sometimes fraught with peril. Richard's son Bob, who accompanied several others on the 1955 trip, recalls watching men with blowtorches in the frigid cold heating up the engine of their snowplane so it could start. Standing about chest-high, this two-person Call-Air coasted across the snow on three skis, powered by an 85-horsepower prop in the back. It was tight quarters for human occupants after they had loaded their bedrolls, a change of clothes, a shaving kit, tool kit, some food and Richard's camera gear, including his hefty 4x5 and two Leicas, weighing as much as anyone's full duffel bag.

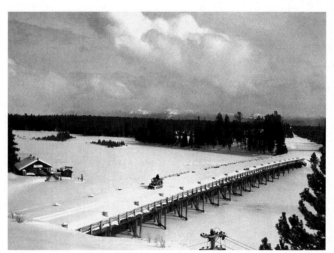
An oversnow vehicle creeps across Fishing Bridge. (1964)

Snow had been falling steadily the night before Jack headed out from Mammoth in 1964 for a four-day trip from winter cabin to winter cabin deep in Yellowstone's undeveloped regions. That morning, a nervous and blustery wind whipped the snow in eddies and sheets, slashing visibility to 20 feet. Settling into his seat in a rebuilt World War II surplus "weasel," Jack was just getting used to the slightly rocking motion and constant patter of caterpillar treads digging into the deepening snow when he felt himself "passing through a barrier" beyond civilization.

"We climbed through the Hoodoos and out onto the wind-swept bare roads of the Golden Gate. With each twist or turn in the highway, gigantic, sloping drifts, extending from the solid cliffs to deep chasms at roadside, pitted our weasels between forward and sideward motion. At the head of the canyon, where the road moves out across Swan Lake flats, we were greeted by an absolute whiteout.

"The wind, which had been buffeting us from all sides as it bounced off the cliffs, increased in velocity and settled down to attacking us at right angles. As we moved out on the flats, visibility dropped to almost zero. The snow, driven at gale velocity, lashed out at us and every other obstacle in its path. All signs of the road were erased in the white, unbroken vastness of the meadows; only snow poles remained to guide us. Ranger Dale Nuss, already driving the road by memory and feel, would stop and wait for the wind to catch its breath long enough for him to see 50 feet ahead. Forward speed, which had been around 10 miles an hour, now dropped to three or four. All of us kept our eyes glued ahead, but, despite our best efforts to see, we occasionally drove off the road into deeply drifted barrow pits."

For Richard, the success of a Yellowstone outing depended on the whims of weather and clouds and their impact on his depth of field and shutter speed. He would become crestfallen when deep layers of storm clouds obscured the sun, restricting his photography to a "monochromatic outline of beauty and fanciful image just a shadow away." Yet one can almost see the broad grin enliven his face and hear him break into a whistle when a shaft of sunlight spears the clouds to illuminate those "ghost trees" covered in frost from the hot springs and steam vents of Hell Roaring Mountain.

Richard's ambition to disclose out-of-the-ordinary perspectives took him time and again to Yellowstone's secretive places, as well as its famous attractions such as the Lower Falls of the Yellowstone. During the course of a mid-winter trip, he would strap on snowshoes and trudge to the canyon's edge to marvel at the sight of "hundreds of tons of ice cloaking the fall's cascading streamers of water and muffling its familiar thunderous roar." To

photograph the falls at its most spectacular, at high water, he would hike to the bottom of Red Rocks Trail—packing 70 pounds of photo gear on his back. He photographed the falls, and Yellowstone at large, by foot, horseback, snowcraft, watercraft and, finally, by air.

Piloting himself on solo flights, or flying as a passenger with numerous other pilots, Richard trained his lens out the window as the plane surged toward the jagged tops of the main range of the Rockies. He watched the mountains become higher, the peaks sharper, the valleys deeper, as the plane, propelled by its steadily droning motor, crept over the last of the ranches and the summer home of the mountain sheep. Suddenly the upswing of the high country beneath him stopped, teetered on a sharp divide and "plunged, with a sweeping curve, into the heart of the Yellowstone."

"The vast expanse of the wonderful West spread out before us, rugged peaks appearing like tiny mounts, the gapping canyon of the Yellowstone like a knife mark across a world of green and white."

At times like these, soaring over the countryside in a Super Cub 135, on a good day—good for flying

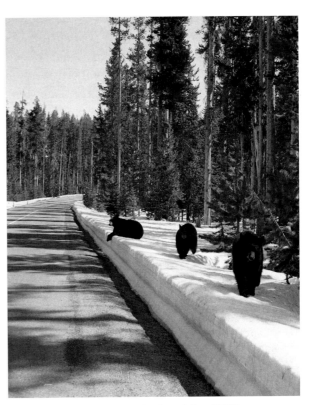

Three black bears await a springtime visitor. (1956)

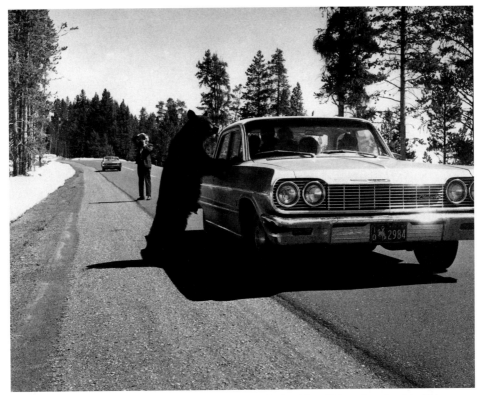

A photographer lines up a shot of a black bear begging for food from Yellowstone tourists. This was a common sight through the 1950s, even though feeding bears was prohibited. (1957)

7

and good for photography—Richard from an altitude of 19,450 feet could observe the Teton Range jutting up like pencil points from the rolling countryside and the distant ranges of Montana, Idaho, Utah and Cloud's Peak of the Big Horns— some 176 air miles to the east. On a fine, sunny day like this, Yellowstone may indeed have appeared as a park, set aside for the nation and in his heart, as a special corner of a broad-ranging neighborhood of landscapes, wildlife, and men and women forging the life and times of a vaster Yellowstone Country.

Rangers once patrolled Yellowstone Lake and Fishing Bridge on horseback, visiting with tourists, policing bear activity and checking fisherman's creel limits. At right, a ranger departs Fishing Bridge for Lake Ranger Station at the end of the day. Below, he overlooks the boat docks at Yellowstone Lake. The docks have since been removed. (1959)

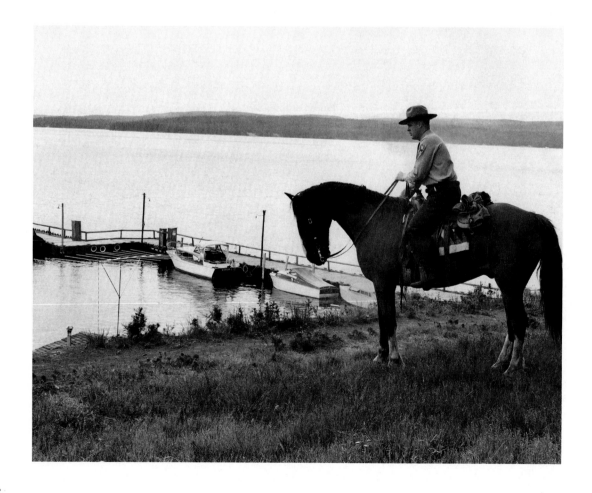

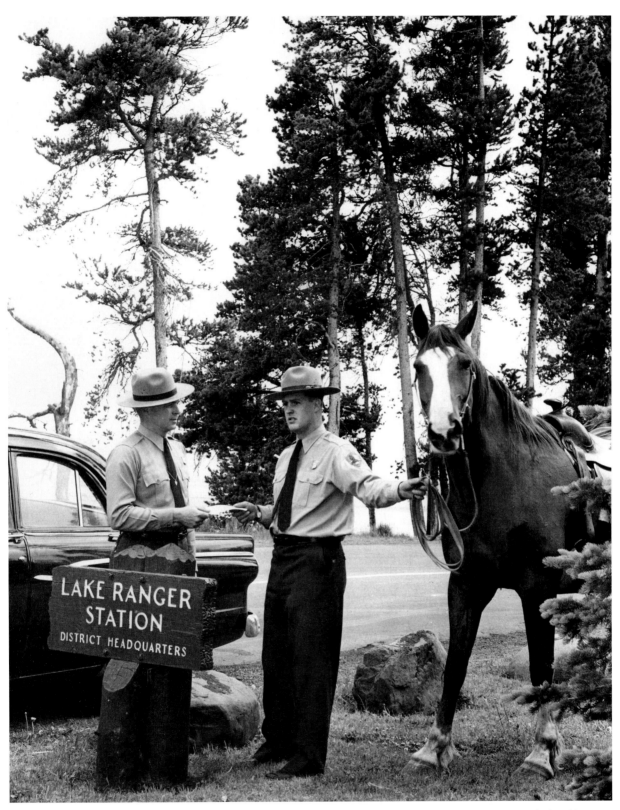

Ranger Bernie Packard provides instructions for the day to horse patrolman Bob Richard. His horse, Big Red, was the last Morgan Stallion owned by the park service.

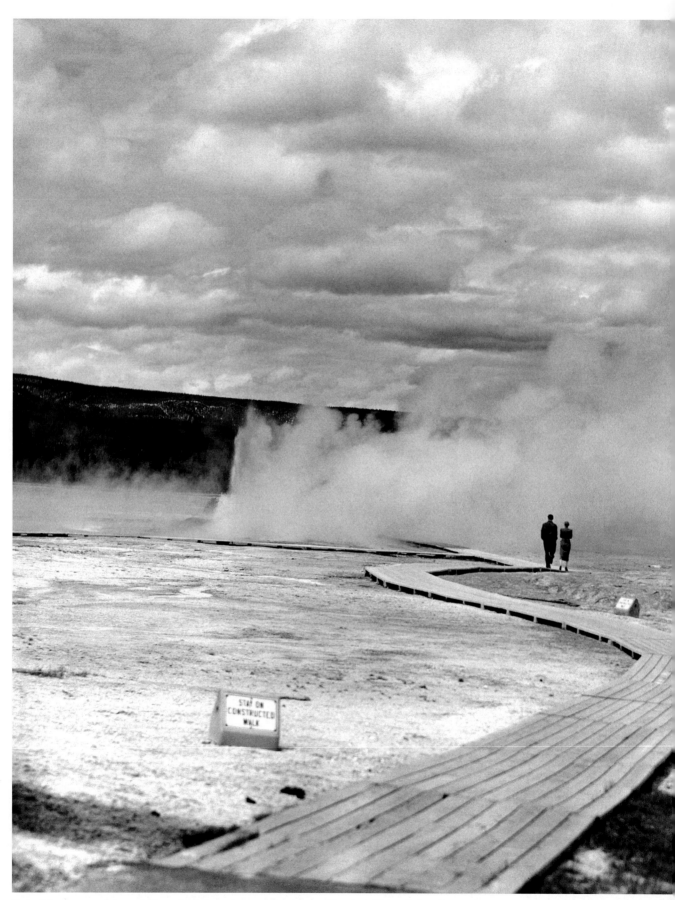

Park visitors proceed down the boardwalk toward an erupting geyser. The Jack Richard photo logo appears at lower right. (1950s)

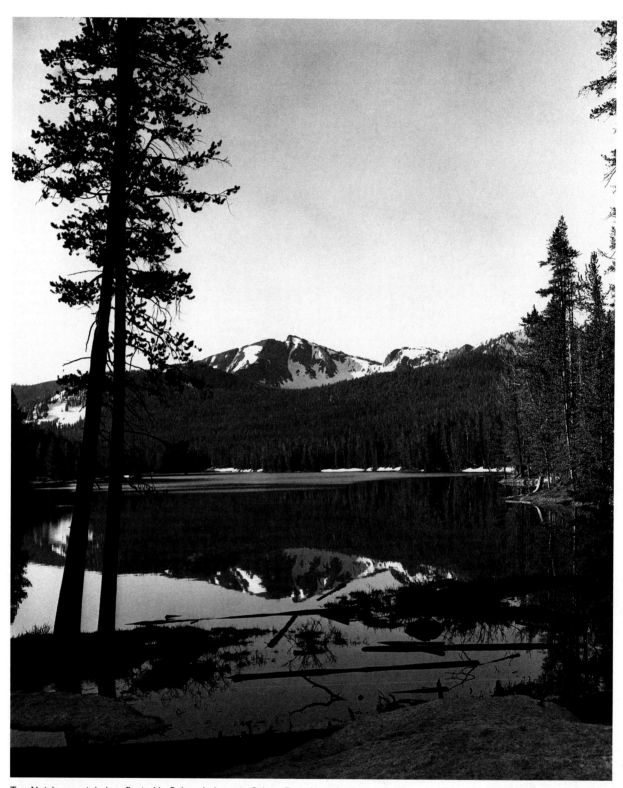

Top Notch mountain is reflected in Sylvan Lake near Sylvan Pass in early June. (1958)

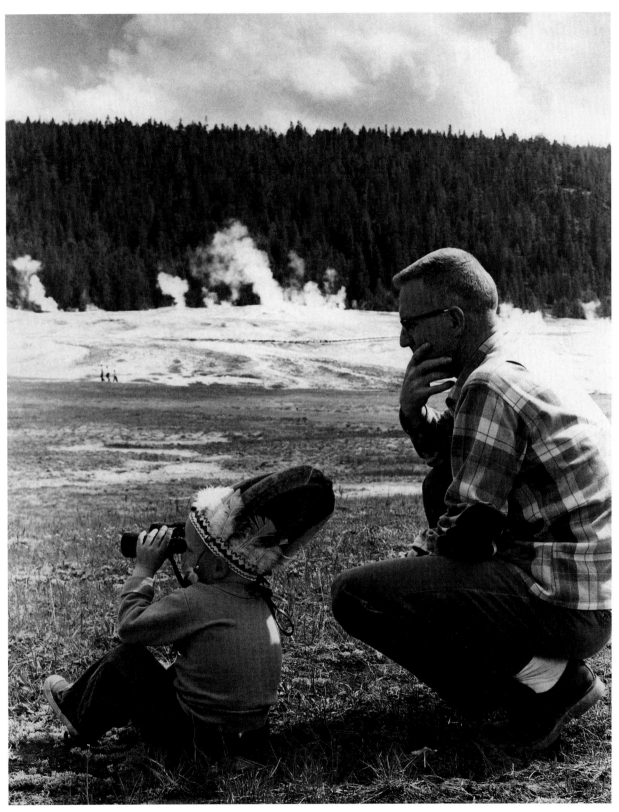

A father and son watch a grizzly and her cubs in the Upper Geyser Basin. (1961)

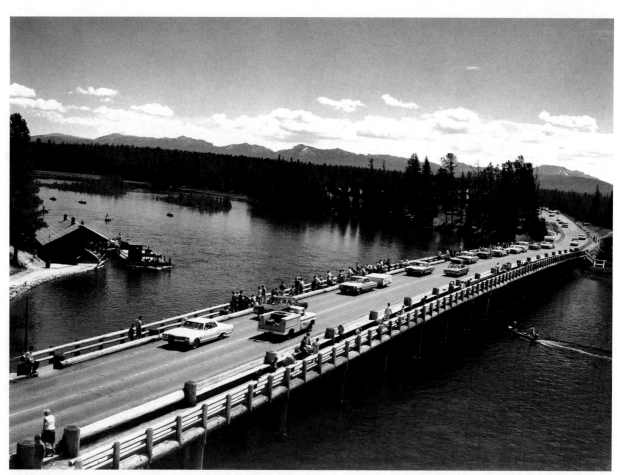

Fishing Bridge and boat docks on the Yellowstone River. (1959)

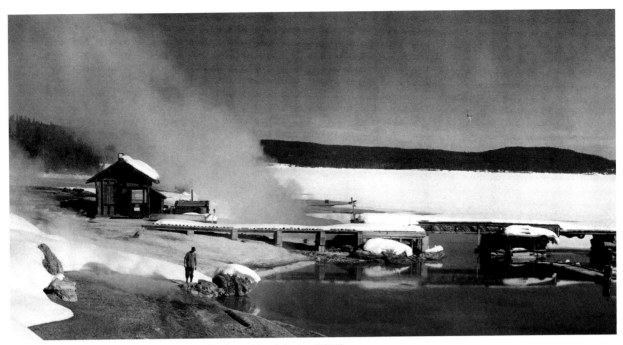

Steam rises from the West Thumb Geyser Basin and boat docks. (1955)

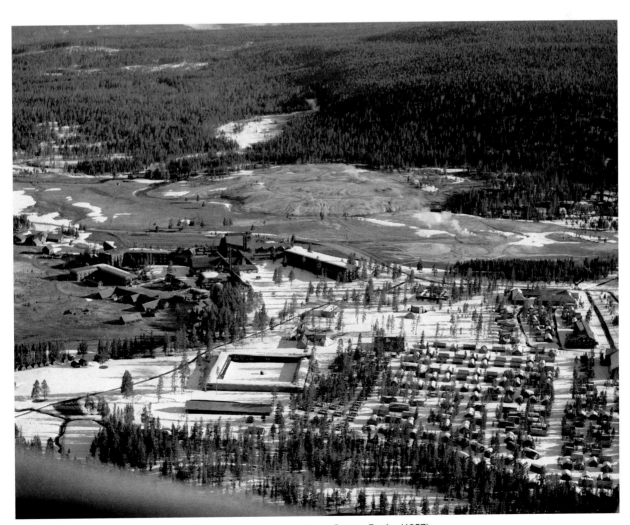

This aerial shows the scope of the Old Faithful complex in the Upper Geyser Basin. (1957)

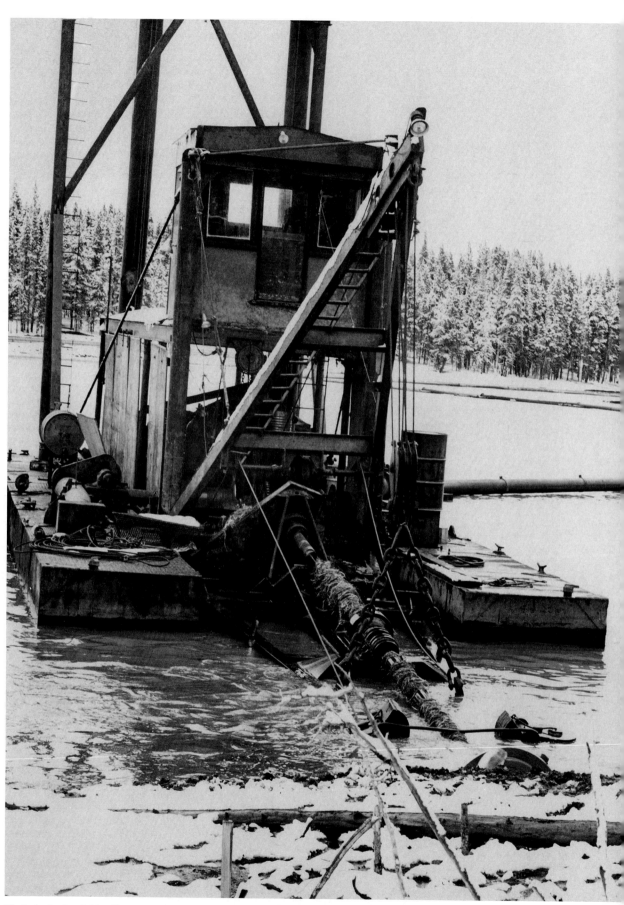

Workers dredge Bridge Bay on a cold autumn day in preparation for construction of boat docks. (Early 1960s)

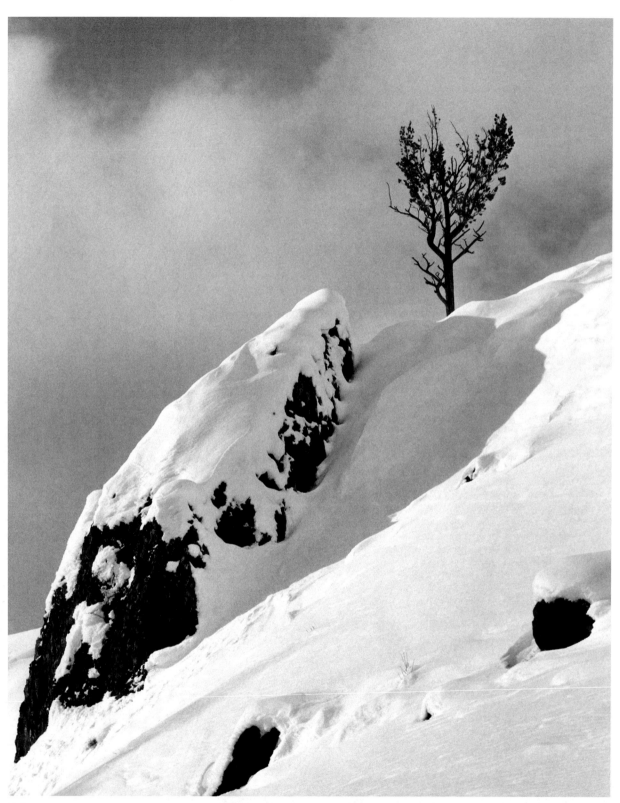

Yellowstone reveals stark and magical beauty during the winter months. (1954)

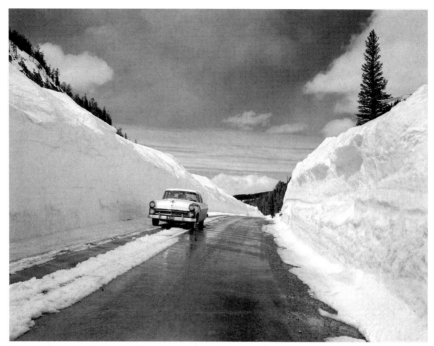

Snowbanks dwarf spring visitors driving over Sylvan Pass. (1959)

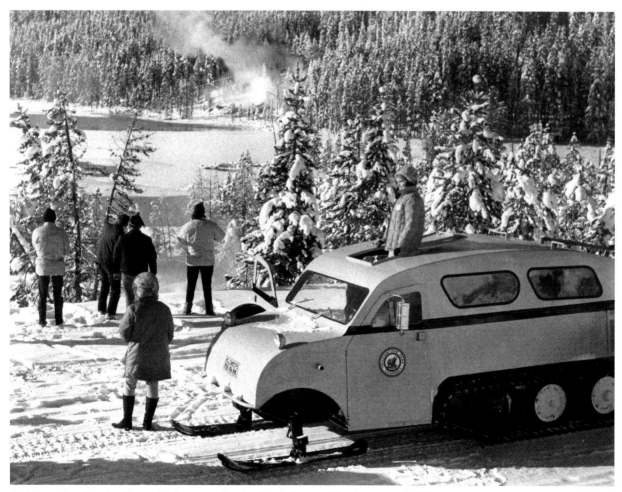

A visitor enjoys the view from a YP Company Bombardier during a public winter tour. (1964)

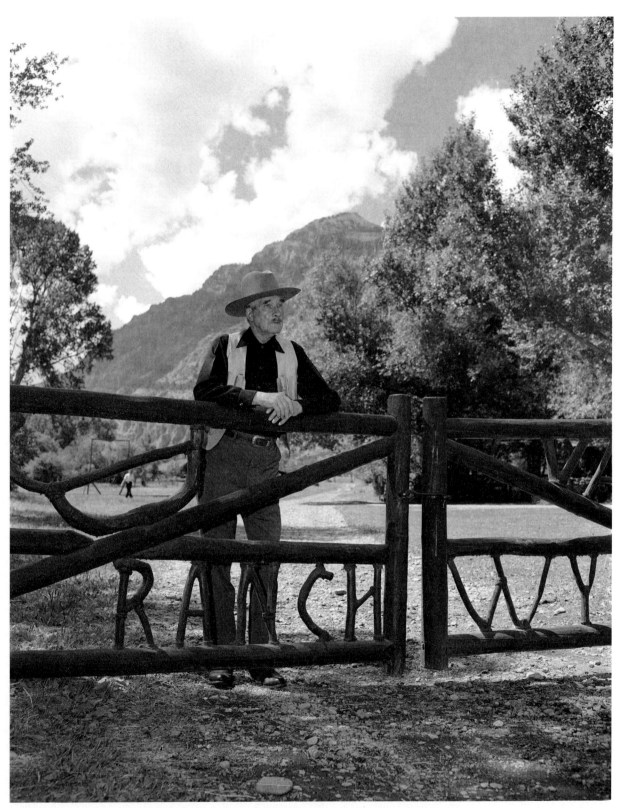

Larry Larom poses at the gate of his Valley Ranch on the South Fork of the Shoshone. (1955)

2.

The Western Way

Reared on a dude ranch west of Cody, I learned to love and respect the mountains and valleys, the wildlife, the people and their way of life. All these I have been photographing for more years than I care to count.
—Jack Richard, 1985

As a boy growing up on a Wyoming ranch, Jack Richard hiked and climbed to the top of many of the foothills flanking his North Fork home. On the verge of his teenage years, his father, Fred, and mother, Margaret, bundled him up in his best dress pants and blazer, cinched up his necktie and launched him and his brother Bob on a challenge to climb a different kind of hill. Unlike the hills of earth and sagebrush he hiked and rode as a boy, this was a hill formed of fine literature, fine arts and rules of conduct designed to turn frisky young boys into thoughtful young gentlemen. The scrappy young man from Wyoming was off to The Hill School, a prep school north of Philadelphia where a stern headmaster and faculty would refine his character and foster his sense of responsibility for the common good.

Jack's regimen of chores on the ranch back home, and his early education in the one-room Wapiti School, had already drilled him in traits of honesty, self-discipline and teamwork. Yet this deeper immersion in thoughts and principles in the stately confines of an eastern prep school struck a chord that rang through his life, and his life's work, like the motto of The Hill School from Philippians 4:8, "Whatsoever things are

true, whatsoever things are honest, whatsoever things are just, whatsoever things are pure, whatsoever things are lovely, whatsoever things are of good report: If there be any virtue, and if there be any praise, Think on these things."

While inspiring and directing the intellect of a young man like Jack, the prep school would channel his eager zeal for physical strength onto the athletic field for lessons in mutual trust and respect in the context of competition and team play. In that context, while lining up for a football scrimmage one autumn day in 1927, Peter Wilson peered down the row of offensive linemen getting set next to him and took notice of "this little squirt with big lips." He was small but muscular with a rugged face.

This friendship forged on the football field and in the dormitory and study halls of The Hill School

21

would last for 65 years, bonding Wilson to Richard throughout his life as he graduated from Cody High School and the University of Wyoming, served the military as an air intelligence officer, and launched his career as a newspaperman, studio photographer and freelance photojournalist.

At the age of 90, reflecting on his youthful days at The Hill School, Wilson recalls facets of his friend's character that were obvious even then. Even though Jack and his younger brother Bob came from a far-off place and culture like Wyoming, their natural grace and charm made them popular with other students. The prep school polished Jack's character through a broader education, new associations and an extra measure of discipline. There was another trait the school didn't need to teach him because Jack had packed it there with him. This characteristic flared up when some fellow students decided to test his strengths and weaknesses through the ritual of the fistfight.

"He had more guts than you could shake a stick at," Wilson says. "He never complained, and he always went back for more."

At the age of 18, Wilson received advice from his doctor to spend his summer in a dry climate for health reasons. He knew the Wyoming climate was dry, and he had friends there, so he sounded out Jack and Bob about the idea of summering with them at the Frost and Richard Ranch. In the spring of 1928, he headed west in his Model A Ford for the first of seven summers destined to become the time of his life.

"It was one of the damnedest existences you could have," he recalls. "We were all young, happy and having a great time."

Scrambling out of bed about 4:30 A.M., "the triumvirate" of Jack, Bob and Peter was up and out the door to perform a routine of chores. Peter often rode the back section, leading the horses down to the corral, before sitting down to a "tremendous breakfast" of stewed fruit, oatmeal and toast, bacon and eggs, pancakes, coffee and fruit juice. They would need that much fuel to power them through their day.

As the "elder statesman" of the trio, Jack laid out a work plan revolving mostly around the care and preparation of horses. Depending on the season,

Peter found himself shoeing and branding horses, riding a few to get some of the pep out of them or saddling as many as 40 horses for the guests. After morning chores, the trio would lead guests on horseback tours into the countryside for a day of fishing or a day's ride to the top of Table Mountain and back. Whether they were heading out for a day or two or a two-week pack trip through Yellowstone Park, the guests were "enthralled" as they rode up the trail.

Jack shouldered responsibility for these trips, and he was most often the one who took the lead to entertain guests around the campfire. Having learned the storytelling trade from two of the best—his father, Fred, and his uncle Ned Frost—Jack was sharpening a craft he would later put to work in the stories he wrote for newspapers and magazines. Back in those days around the campfire, taking command of an audience of newcomers to the West, Jack

Don Pond at camp. (1954)

and his comrades couldn't resist stretching the truth some as they spun their yarns to wide-eyed dudes.

Along the course of those long summer days, seeming all the longer from the timeframe of their youth, the trio found time for some good-natured horseplay. Peter was always vigilant for an attack from behind because he never knew when it might strike. Bending over to shoe a horse made him especially vulnerable to a pinch on the hindquarters. A good strong pinch felt like a horse bite. That made him jump, and that was the point.

Sometimes when the mood strikes him, Wilson pulls from his bookshelves a videotape of rough motion pictures he filmed, scripted and directed during his summers on the ranch. Flickering like a black-and-white flashback to the West of the '20s

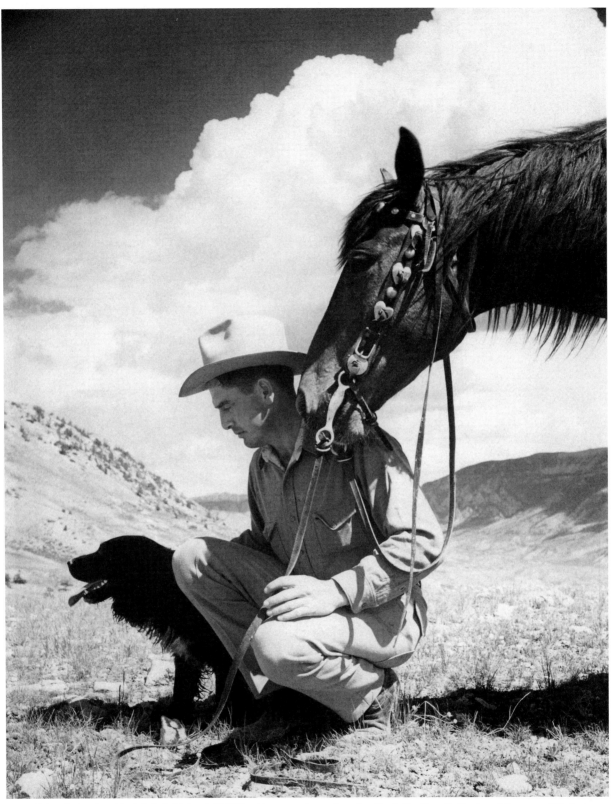

Jack Richard's brother, Lt. Col. Bob Richard, USMC, at home on leave from the South Pacific with his dog, Johnny, and his horse, Bay. (1943)

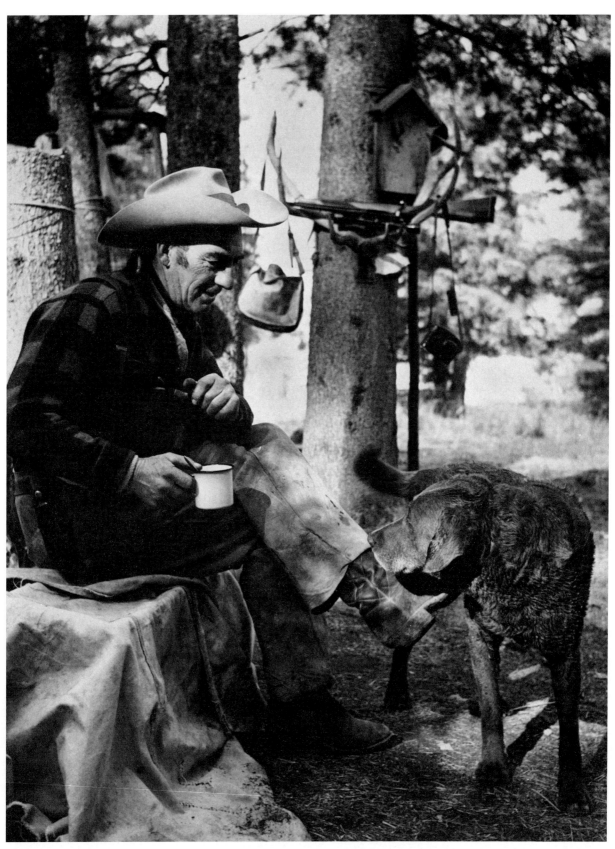

Outfitter Bob Adams savors a cup of morning coffee at a hunting camp on Elk Fork. (1960s)

and '30s, the homemade movies unfold vignettes of three heroic boys always facing some perilous danger or launching some adventurous rescue. In one scene, Jack and Bob storm out from a barn and point intently at the sky. No one knows or remembers why the brothers struck such a dramatic pose, and it hardly matters. It was just fun.

The moving pictures reveal more scenes of Peter, Bob and Jack duded up in fantastically big cowboy hats and chaps to perform their trick riding. Swinging off to the side of a galloping horse, Bob plucks a hat from the ground while Jack attempts an aerial maneuver—leaping upside-down off "Little Buck" and landing on his feet.

"We would put on our own rodeo to entertain the guests," Wilson notes. "Somebody would ride a yearling steer, or we'd rope some logs or do a little trick riding for them."

These were summers full of adventure—close encounters with bears, moonlight encounters at the girls' camp, a two-day horseback trip to a barn dance at the TE Ranch, or the annual trek into town for Cody's celebration of Buffalo Bill's birthday at Wolfville Hall. With its whirl of dancing and roulette wheels, this was the place where "Cody went to howl."

"It was not necessarily a peaceful country," Wilson notes. "One night I saw a man pull out his knife and just open up his opponent."

Even though Richard had yet to pick up a camera with any serious intent, his youth was tinting his character in ways that filtered through his pictures in later years. While his prep-school education rounded his edges and inspired him to higher thoughts, his upbringing on a dude ranch gave him a natural feel for his favorite subject. Like his emerging character, his photos would merge the gentle and the tough, the poetic and down-to-earth, and the artistic and the raw.

Looking back on his photos in 1990, only two years before his death, he traced this "silver thread" that wove his work together.

"My earlier life experiences had a definite influence on my selection of subject matter," he

Competing in the Cody Stampede. (1950s)

said. "I was born and reared in the out-of-doors: ranching, big game hunting and fishing, wildlife of all kinds, mountain scenery, wildflowers, cattle and sheep and the history of each of them. This interest, or sincere hobby, has been like a silver thread woven into my life from an early age."

The uncomfortable barrier of the camera lens dissolved when Richard photographed a cowboy savoring a morning cup of coffee, a sheepherder watching over his herd at night or a rancher carrying a calf from the chilly snow into the warmth of a barn. Richard had lived their lives and understood their work.

"He was comfortable around the outdoor way of life," his son Bob says. "He talked their language and he portrayed their feelings."

Although he rarely commented on his own work, Richard was a student of Western photography and felt his photos filled a slot in the photographic history of ranch and livestock activities in the Cody region. He saluted the "old-time photographers" who recorded posterity in the early 1900s before Charles Belden, the "Famous Cowboy Photographer," set up camp on the Pitchfork Ranch outside Meeteetse.

Richard once observed that Belden, a good friend of his, photographed working-day scenes of ranch life rather than the "glamorous" side of the cowboy. At the same time, he noted, Belden had the ability to turn the usual into the unusual. Whether Belden's influence was direct or indirect, much the same could be said of Richard's photos. Belden covered cowboy and ranch life from 1914 until his departure for Florida in 1940. That's about the time Richard picked up the trail and followed it through the 1980s.

This legacy of visual images "pulled down the curtain" on some parts of the West, Richard said, as gasoline motors replaced teams of horses and oxen and new breeds of cattle intermingled with the herds of pure, white-faced Herefords that once dominated the grasslands by the hundreds of thousands. While documenting changes in real-life

ranch work, especially during the 1950s and 1960s, Richard felt nostalgic for the earlier West and scouted for views of the cowboy's timeless spirit. For those who missed the Old West, he wrote in 1959, much of it could still be found during an old-fashioned cattle drive, "when things get plumb westerner and downright ornery to be around."

"Oh, sure, the men may have a car to go to town on Saturday night and no longer is there a hitching rail in front of the saloon, but the business of punching cows is still much the same. It has its good moments and its bad. The animals aren't as wild, and they weigh more and are better eating, but they still must go to the mountaintops in the summer and to eastern markets to be turned into cash. The trail herds don't travel as far, but the quiet of the open range is the same, and so is the dust and alkali at the loading chutes."

Gathering photos for newspaper and magazine pictorials, or simply for dude ranch operators to give to guests, Richard found any number of ways to hit the trail to the high country with hunters, ranchers, wranglers and outfitters. On a 10-day packtrip into the rugged Thorofare, his son Bob recalls, Jack packed all his camera gear, including his 4x5 Speed Graphic, 2 1/4 x 3 1/4 Voigt Lander, two Leicas, his filters, tripods, film and a change bag into special panniers his father made for his photo excursions. It was all one packhorse could handle.

These could be rugged trips, yet the effort was worth the reward to experience what Richard called the enchantment of the high country: the pine-scented valleys and snow-encrusted ridges, the chuckle of a mountain stream, and the skeletal pines emerging from the skyline above the twinkle and dance of the campfire.

"The smell of leather, horses, pine and campfire smoke has a special charm and a special place in the heart of everyone who lives this Wyoming Way of Life."

A workhorse nibbles some ice at the Old Frost Ranch on Sage Creek. (1962)

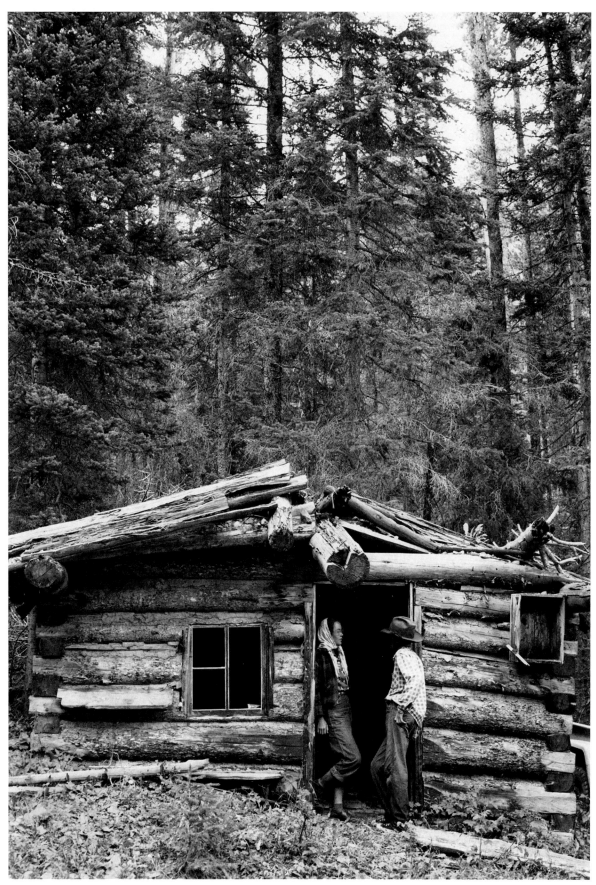

A cowboy and cowgirl at the Lee City ghost town in Sunlight. (1952)

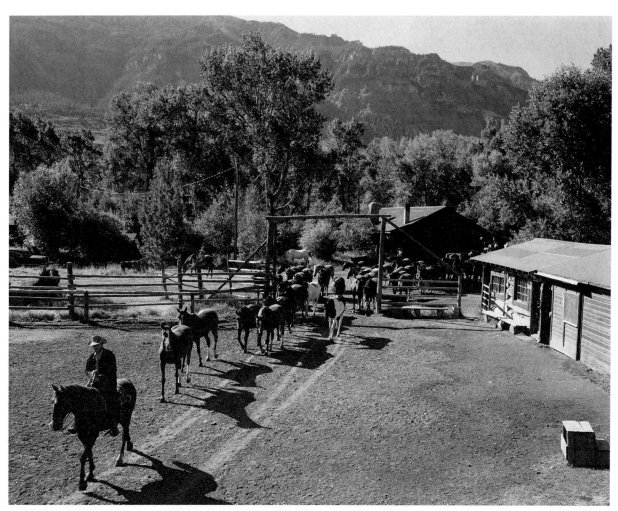

A wrangler corrals horses at Valley Ranch before saddling them for a pack trip. (1964)

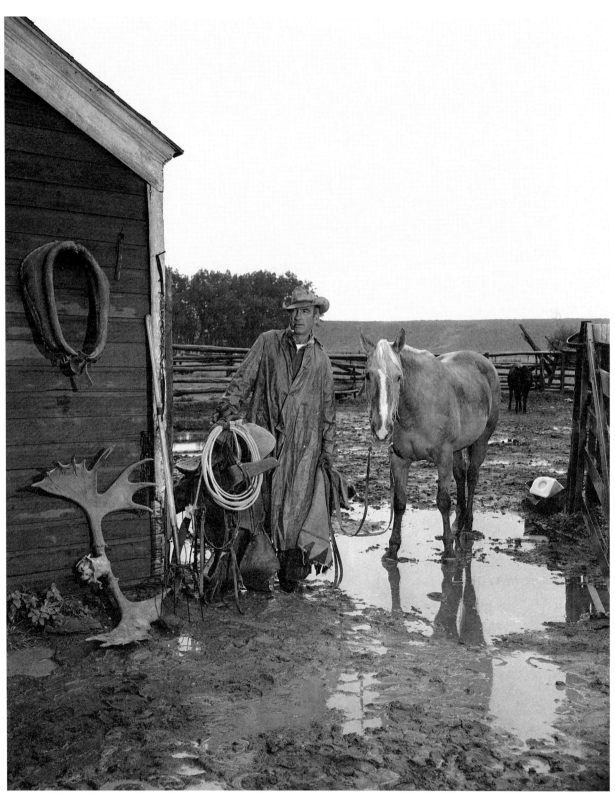

Bob Adams prepares to put up his horse after a rainy ride. (1957)

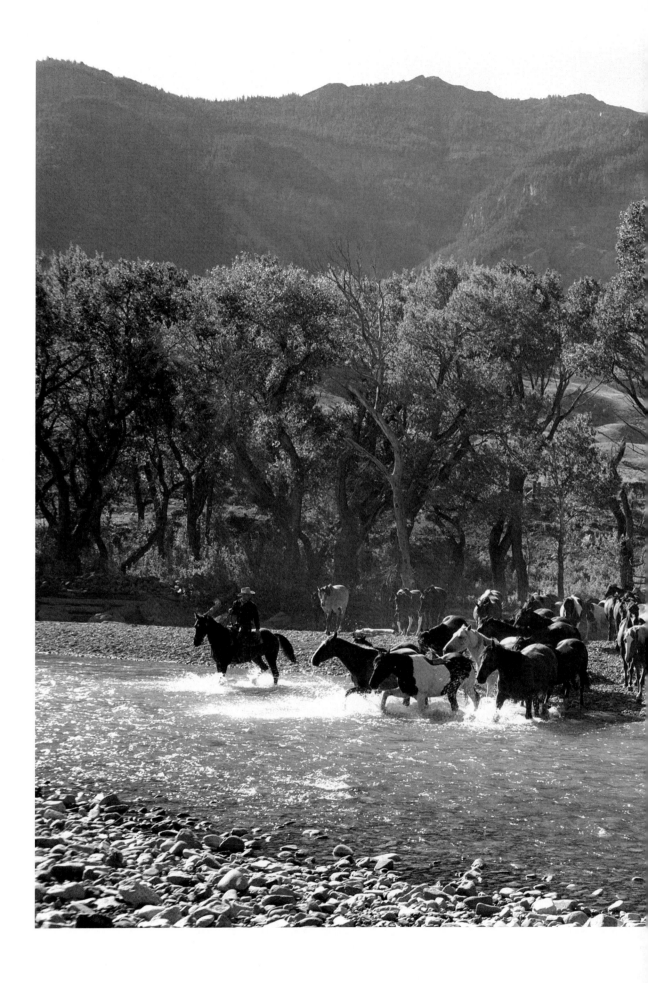

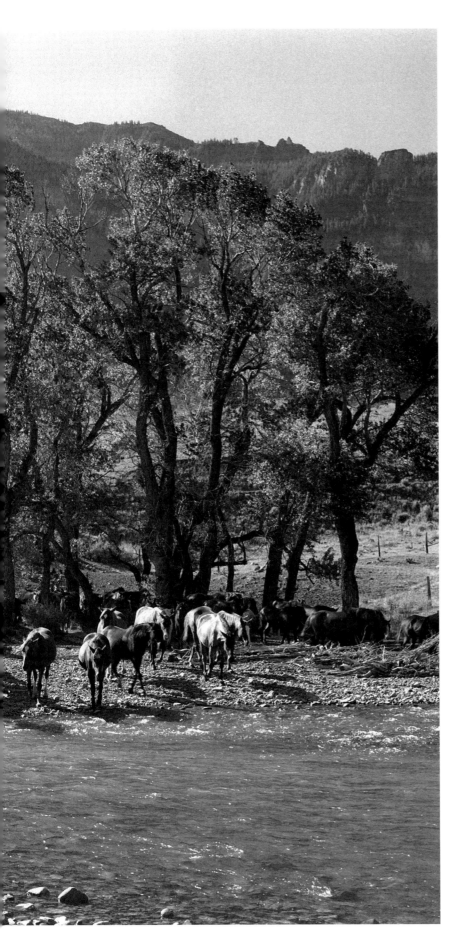

Leading horses across the South Fork of the Shoshone. (1964)

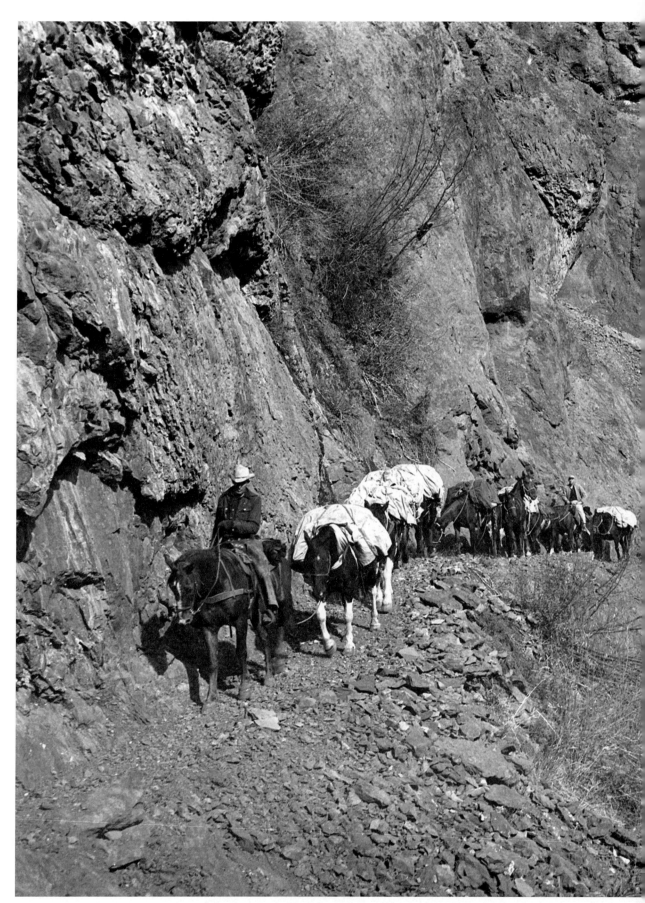

A pack string climbs a trail toward the Thorofare on Ishawooa Creek. (1954)

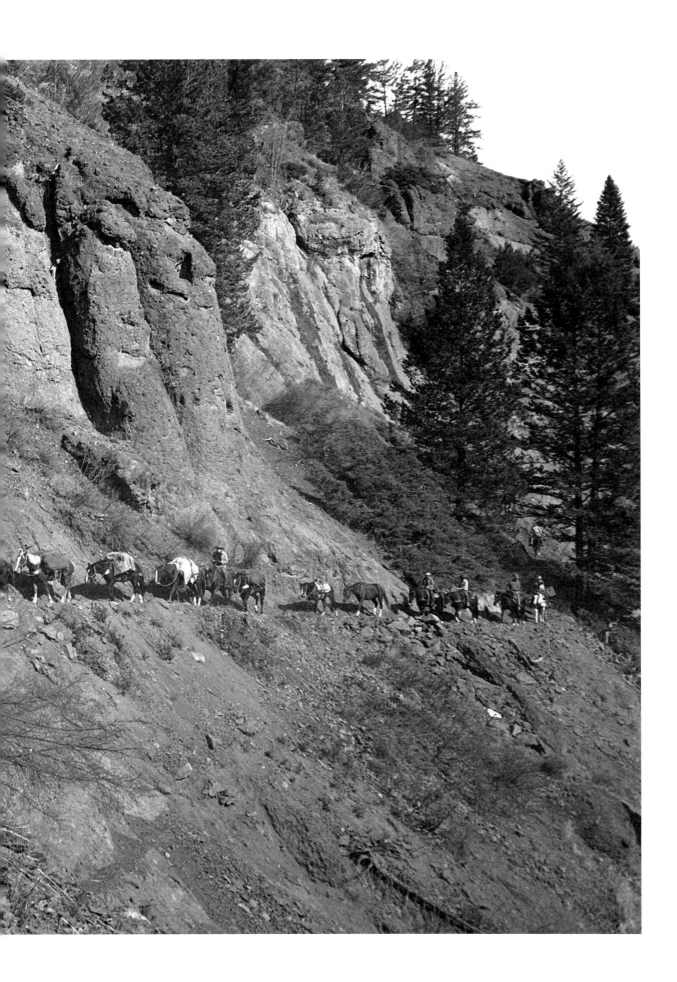

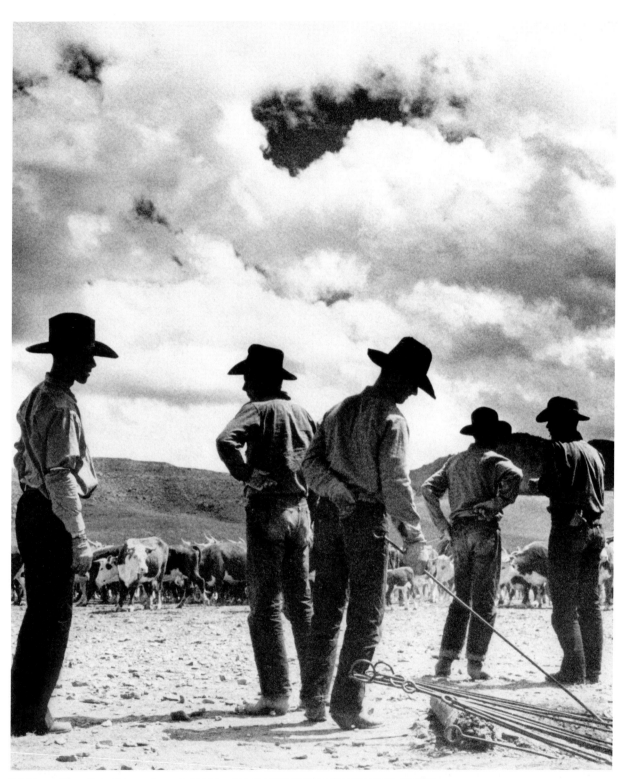

Bright sunshine silhouettes cowboys during branding at a Yellowstone Country ranch. (1960s)

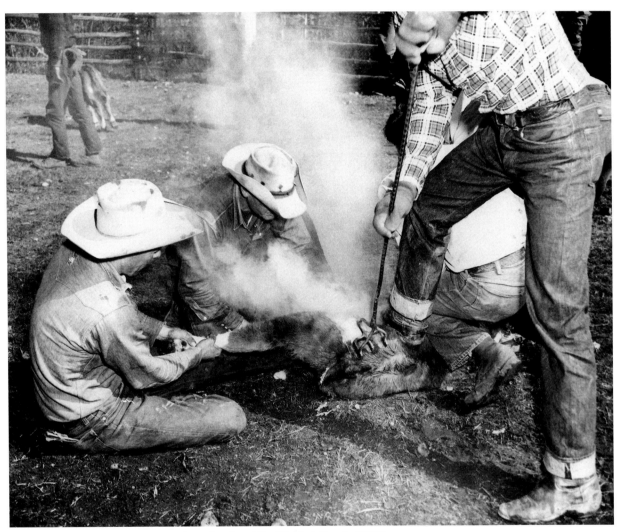

Cowboys work together as a team on branding day at the Pitchfork Ranch. (1954)

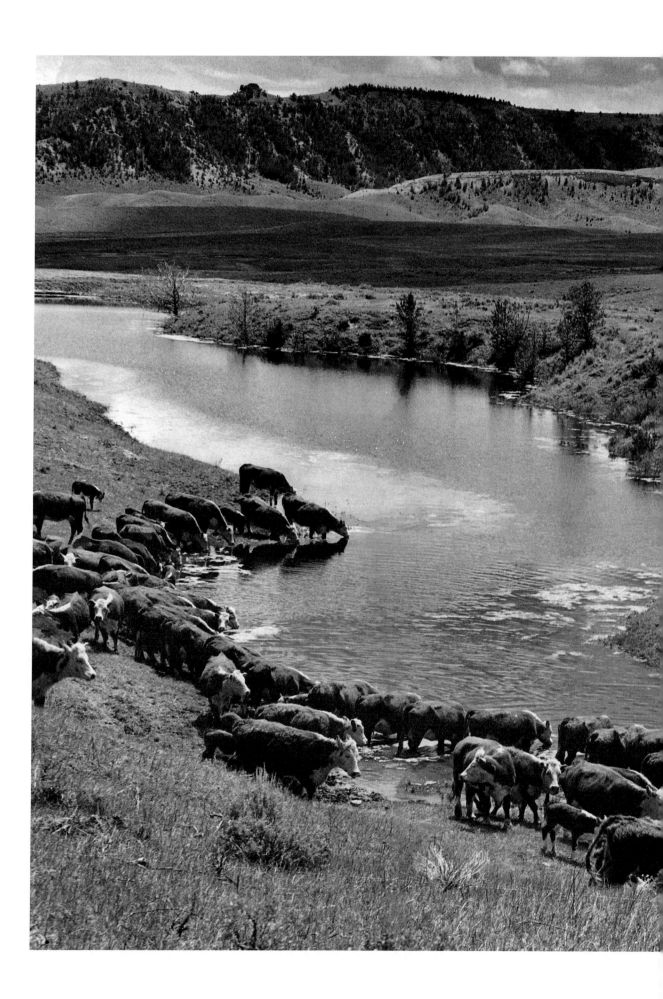

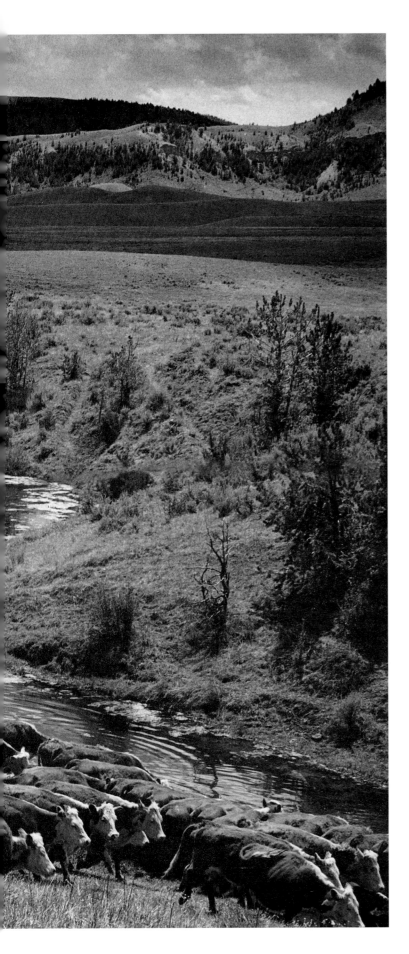

Cattle take water along the Wood River on the Antlers
Ranch south of Meeteetse. (1950s)

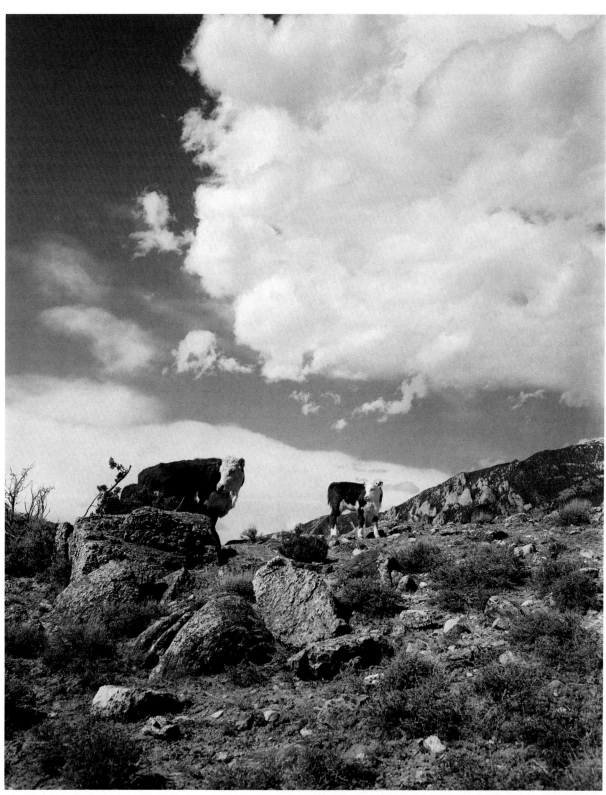

A cow stands with her calf on the bench of Rattlesnake Mountain. (1970s)

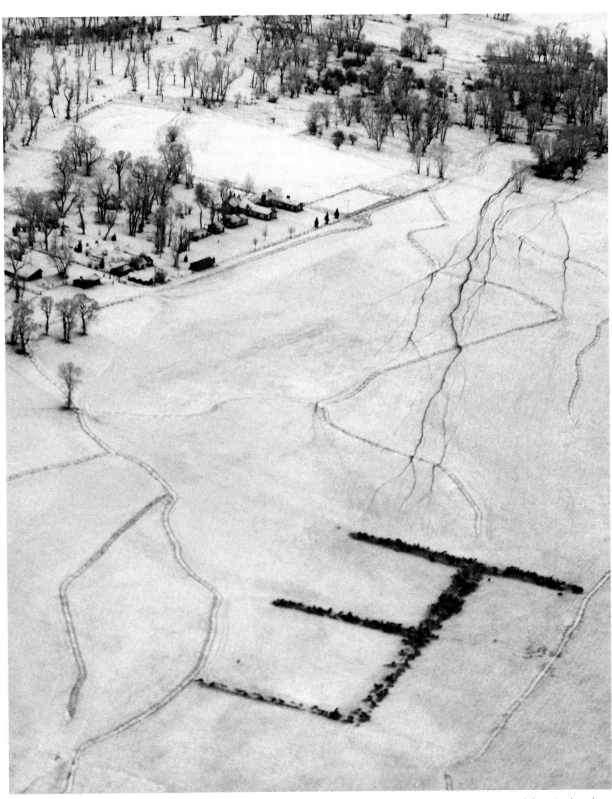

TE Ranch cattle feed in the shape of Buffalo Bill's famous brand. Ranch foreman Dick Loftgarden worked several days to place hay in this formation for Richard's aerial photo. (1959)

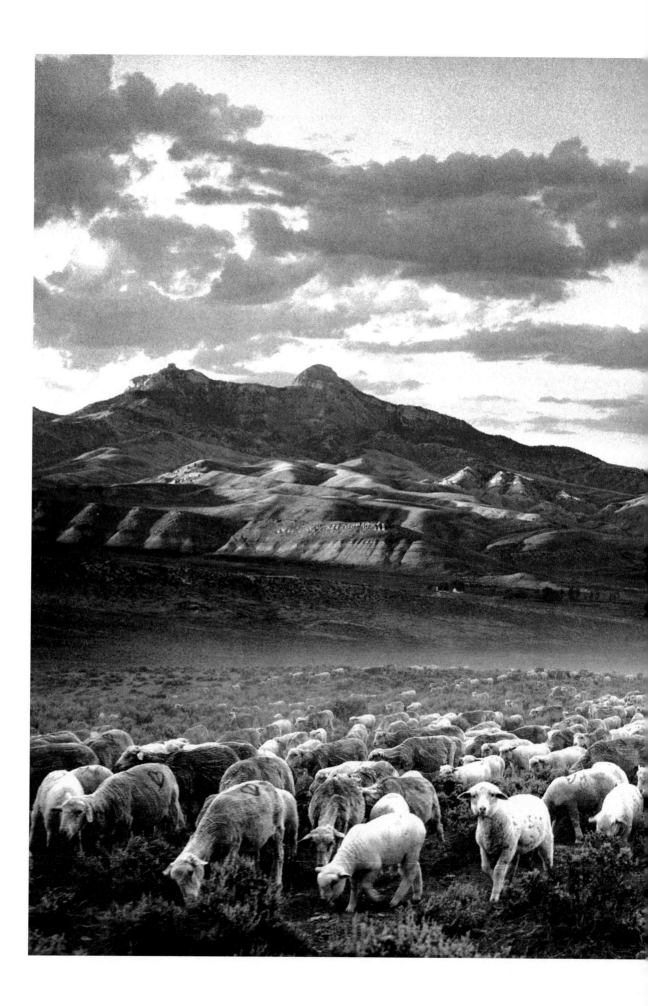

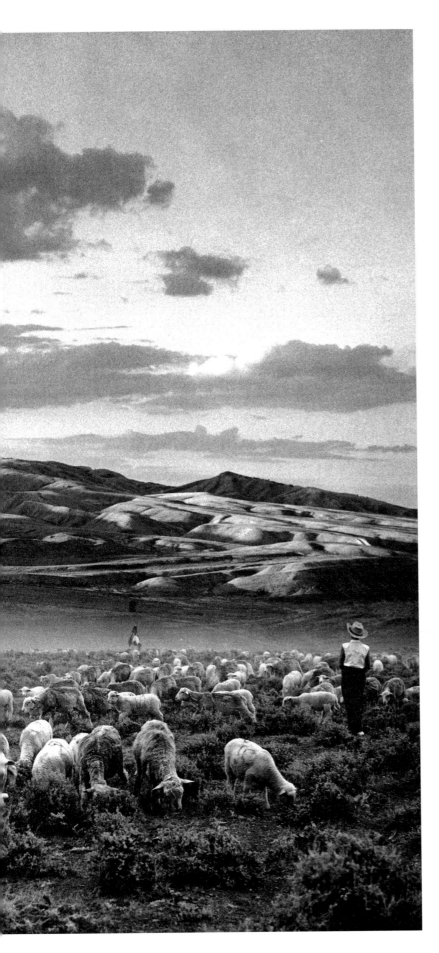

Almost 2,500 sheep are herded from the Quick Ranch toward summer pasture in the Trout Creek mountain meadows as the sunset casts shadows across Heart Mountain. The photo received a special honor from the Rocky Mountain Photographers Association. (1962)

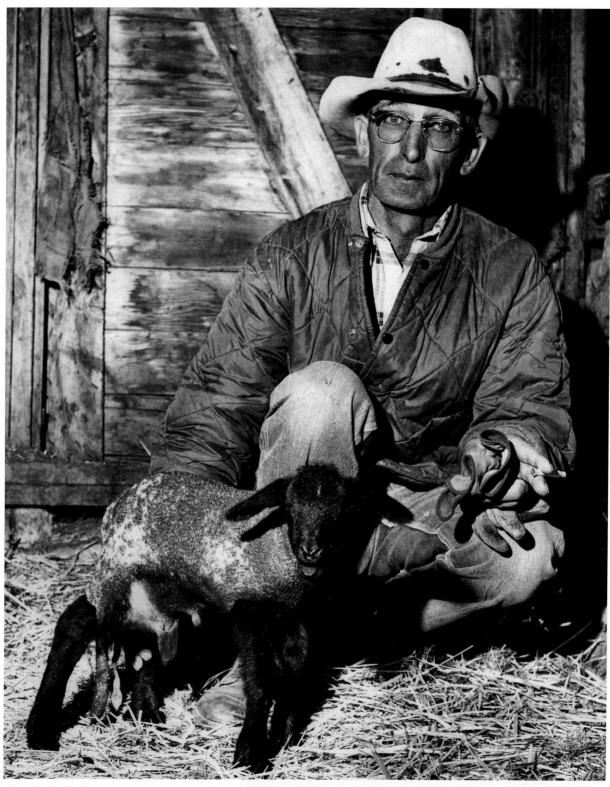

Sheepherder Jim Moots tends to an orphaned lamb in the barn of a Meeteetse ranch. When a lamb is left orphaned, a rancher often gives it to another ewe, but the ewe won't adopt the lamb unless it has the proper scent. To fool its foster mother, the rancher takes the skin of a dead lamb and makes a jacket for the bum lamb. Before long, the mother accepts the lamb as her own. (1965)

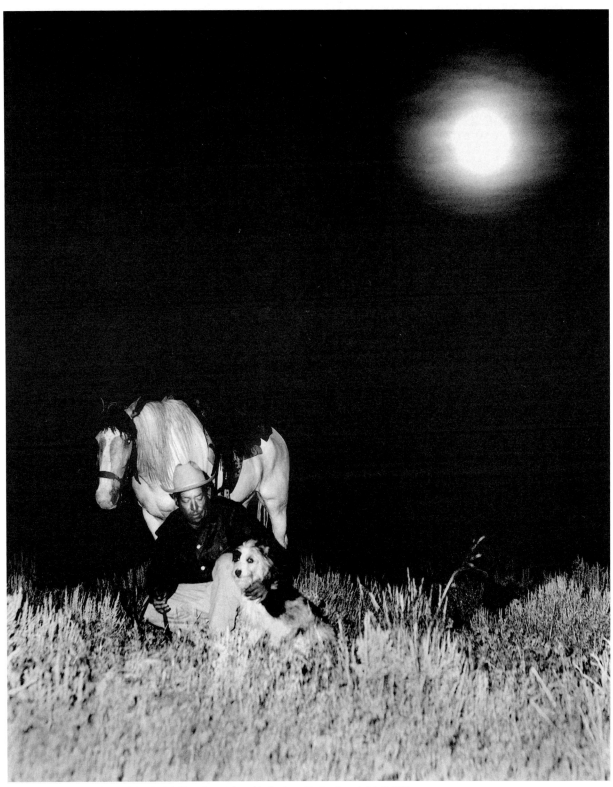

Sheepherder Tony Ortiz of the Quick Ranch watches his flock settle for the night. (1962)

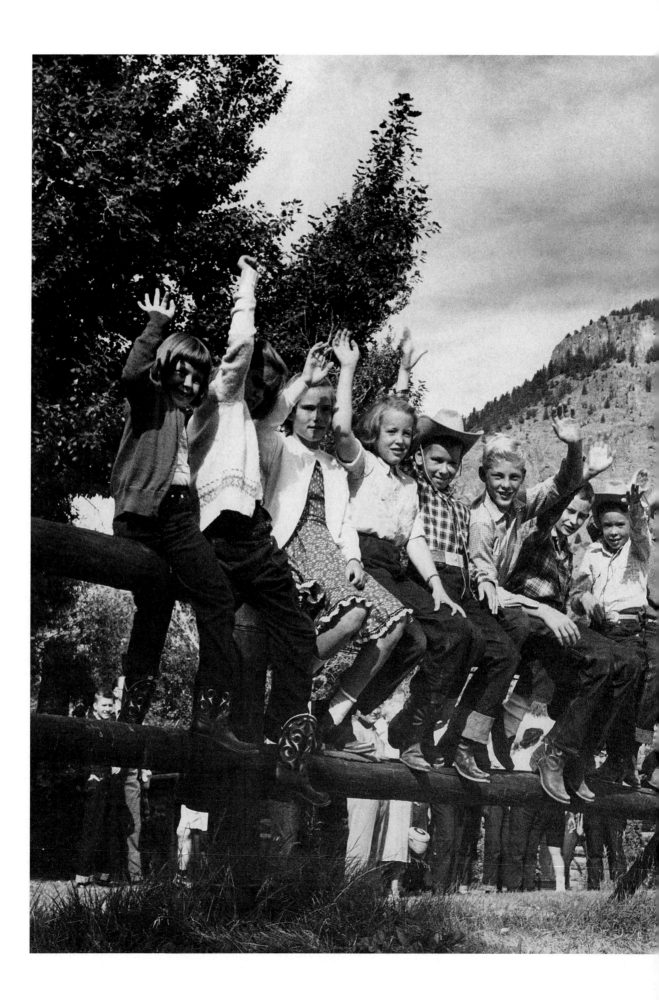

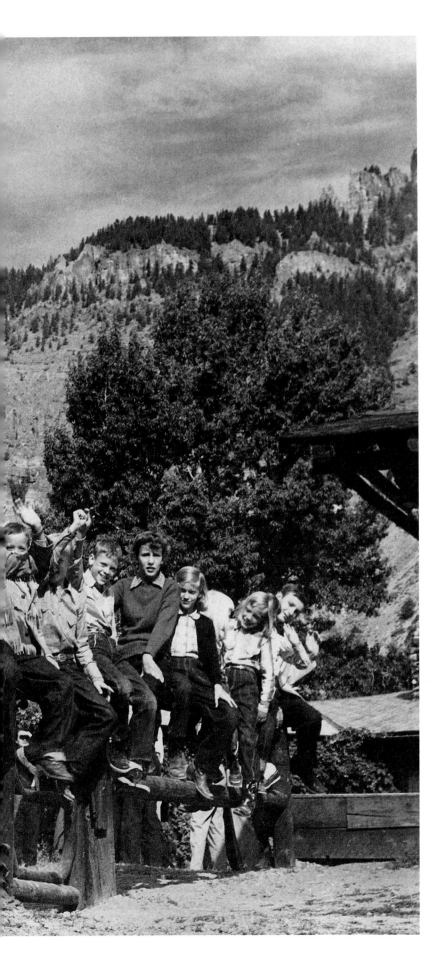

Young guests of the Valley Ranch exhibit some
real Western hospitality. (1964)

3.
Foothills to Heaven

When tired of work He comes and rests
By grass and flowers He loved and blessed.
At sunset all of us must hush
He paints the sky with His golden brush.
—Jack Richard, 1932

Along the course of a river winding through a mountain valley, Mother Nature is working like an artist to paint another picture. This morning she chooses from her palette a selection of crisp whites and dense blacks to paint an archway of flittering leaves and sunlight above a country road to a North Fork fishing hole. This morning her brushstrokes are quick and sharp to achieve the delicacy of beauty in her mind's eye and to match her delightful mood.

In a flash she paints this special of all moments and then she's off, down the road to paint some more. She moves on through the summer, through the rolling plains and valleys, to the high country, where she transforms her landscapes into rugged towers and time-torn cliffs. Along the crown of the Clarks Fork Canyon, she sketches an intricate pattern of snow banks and bare ridges. As dusk approaches,

Mother Nature uses shafts of light from the setting sun to round out the hard edges of her painting, soften the deep shadows, and "sprinkle her favorite world in gold dust and magic."

"At the magic hour of sunset, when the breezes quiet and a lulling hush settles over the mountain country," Jack Richard writes, "a man can cast aside his worldly worries, make peace with his soul, and enjoy life for the pure love of living."

In pursuit of his love of living through all this country God and nature made, Richard always seemed to be hiking and horseback riding on a trail leading up from the tough and merciless plains to the mountain meadows where the grass was tall and green and wildflowers sprinkled the hillsides. Richard would climb still higher, like a character in a book of poetry he printed at the age of 23, to a vantage "where the rugged mountains stand unbowed and hide their lofty heads in clouds."

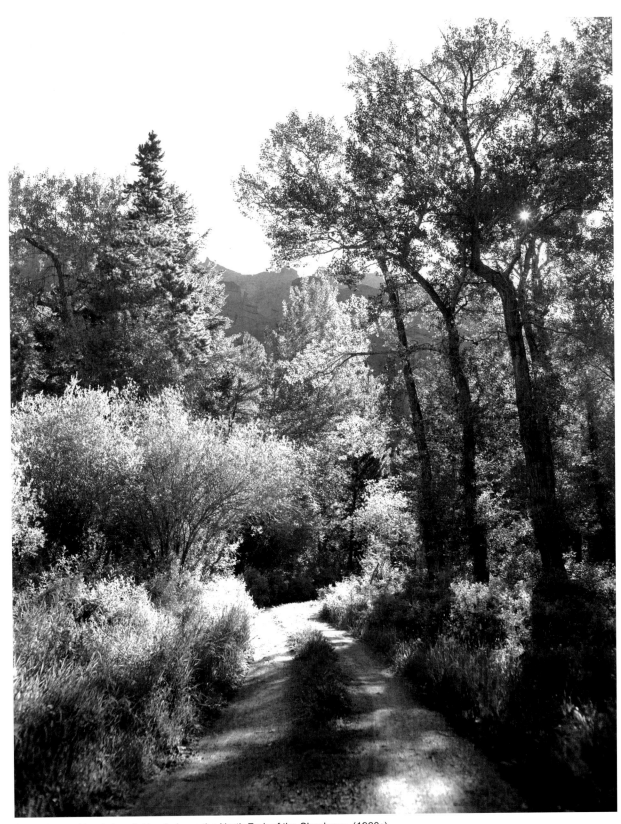

A country road leads to a fishing hole on the North Fork of the Shoshone. (1960s)

Horses graze near a hunting camp in Eagle Creek Meadows. (1954)

Of all the scenics and landscapes he shared on front pages of *The Cody Times* and *Cody Enterprise*, the aerials Richard took over the course of more than 30 years of flying were among his most memorable. Flying mostly in the morning, when the wind was calm, he took advantage of stark sunshine and shadows to catch that sharp and elusive contrast he sought in nearly all his pictures. From the fast-moving tripod of an airplane's cockpit, he swept across a panorama from the Grand Canyon of the Yellowstone to mighty Devil's Tower in northeast Wyoming. Having rolled two of his great joys, flying and photography, into one package, he delighted in sharing his view from the clouds with the earthbound.

Propelled by his own love of flying, and motivated by various demands for his work, Richard produced an unrivaled series of aerial landscapes of Yellowstone Country from the 1950s through the 1980s. He was commissioned at various times by the U.S. Forest Service or Park Service to document the high country or by regional companies such as Husky Oil to document their facilities from the air. But mostly Jack worked for Jack—to find pictures he could share with and sell to newspapers and magazines, often accompanied by his news and feature articles.

Light snow crusts Logan Mountain east of Jim Mountain and Trout Peak. (1955)

Crazy Creek Falls on the Upper Clarks Fork of the Yellowstone. (1961)

Mike McCue, one of numerous pilots who flew with Jack over the years, recalls making his rounds at the Cody airport and noticing on many fine summer mornings that one hangar door was open already. It was Jack again—up and out the door at the crack of dawn. Jack was fond of the airport, and well-versed in the vagaries of Cody's winds, because this was the place where he first learned to fly as a curious young man under the tutelage of airport manager Larry Siddle.

Richard divided his flying time with two friends, Coy Gail and Wayne Messenger, who partnered with him to buy a make of plane that was fairly common at the time. Named after its manufacturers, the Funk Brothers, the plane was dubbed, simply, the Funk. Compared to other planes, the single-engine Funk was underpowered for mountain flying, and its tiny cockpit made many feel cramped. But a man of Richard's size could negotiate the cockpit with relative ease and

50

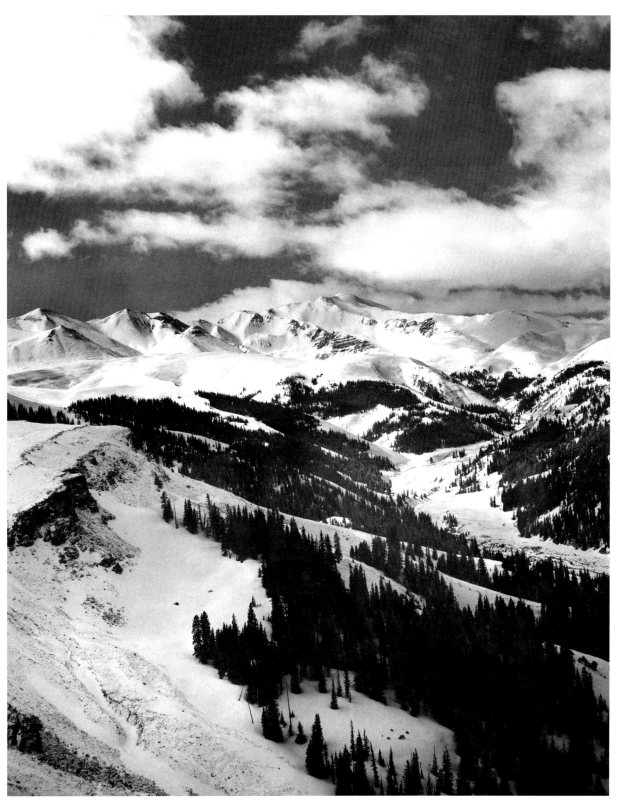

Snow-cloaked terrain in the rugged Frank's Peak country. (1961)

take full advantage of other attributes the plane afforded a flying photographer. The Funk was a stable aircraft—providing a steady platform for a cameraman leveling his wings while taking his pictures. Best of all, this was a plane with its wings on the top—giving Richard a clean shot out the window at the landscapes he was tracking below.

McCue and many other pilots, including Jack Duggleby, John and Ray Elgin, Greg McCue and Clarke Yauger, most often flew for Richard when he was on a specific commercial assignment for his Jack Richard Photo Studio. Flying in the passenger seat gave him extra room to maneuver one of his bigger cameras such as his large-format Hasselblad. When he was working one of these assignments, Mike McCue recalls, Richard was patient yet demanding.

"It took tremendous patience, especially with the kind of wind we have in this country, to get the picture right, and to get the sun just right," he says. "He would have me fly two or three times around one subject. He was very meticulous."

Richard made alterations to some of the cameras and gear he packed into his airplane just as he used custom-built panniers to pack equipment into the mountains. For much of his aerial photography, he was determined to couple his fine German telephoto lens to his 4x5 Speed Graphic. The lens wasn't made to fit the camera, so Richard designed a special coupler, along with a Y-shaped holding platform to bolster the hefty lens as it jutted out the window. His demand for precision and quality as a photographer translated into vigilance and caution as a pilot. While steadying the stick or adjusting the trim tabs along the course of many aerial outings, his son Bob learned much about his father's approach to each pursuit.

"No matter where you're flying, he would tell me, always make sure you have a landing place in mind," Bob says. "If you can't find a landing spot when you're flying in the mountains, you can get in trouble. His philosophy was, don't get in trouble, and avoid the places where trouble lurks."

One can only imagine Richard on his solo flights, setting his throttle and rotating the little

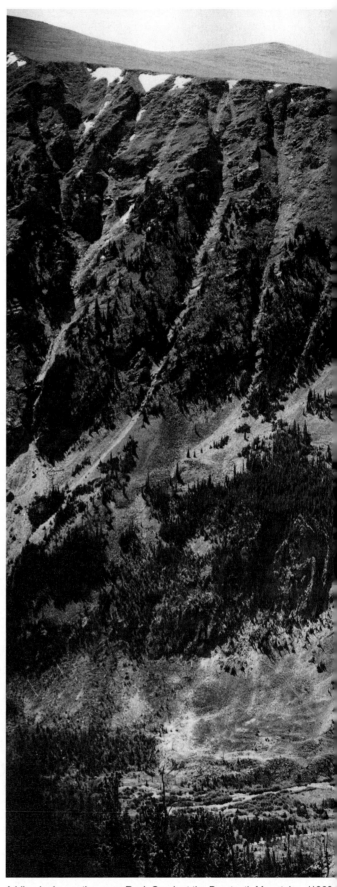

A hiker looks south across Rock Creek at the Beartooth Mountains. (1960s

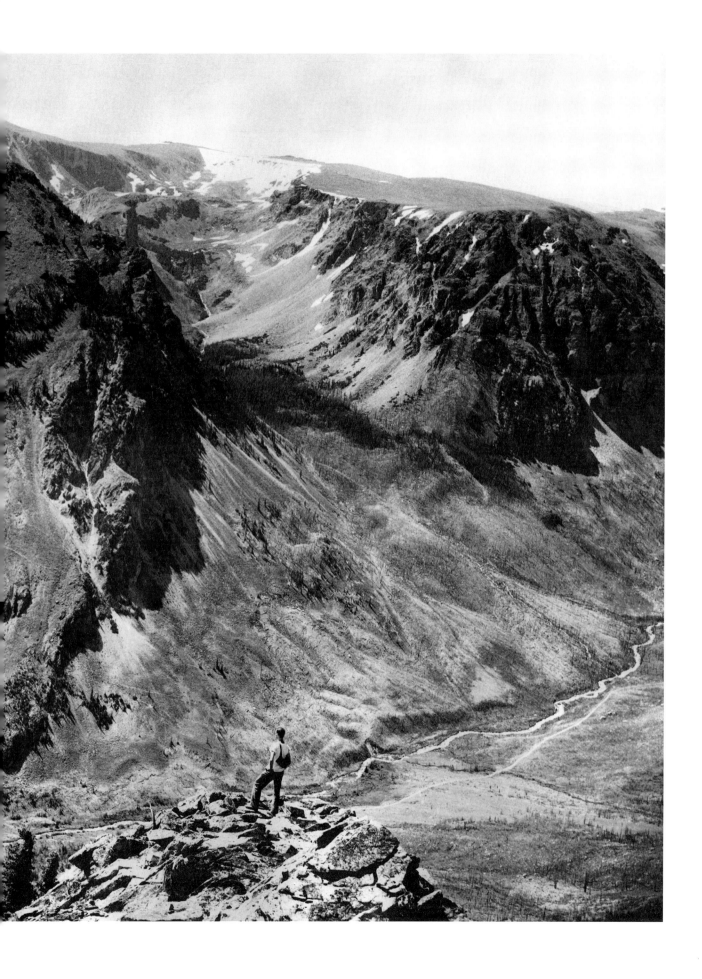

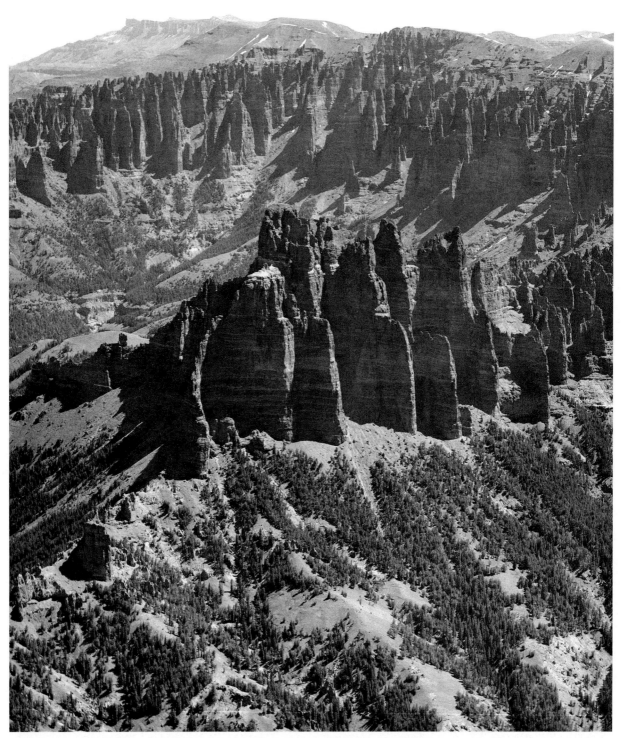

Erosion in a volcanic field left this formation called "The Needles" on the South Fork. (1962)

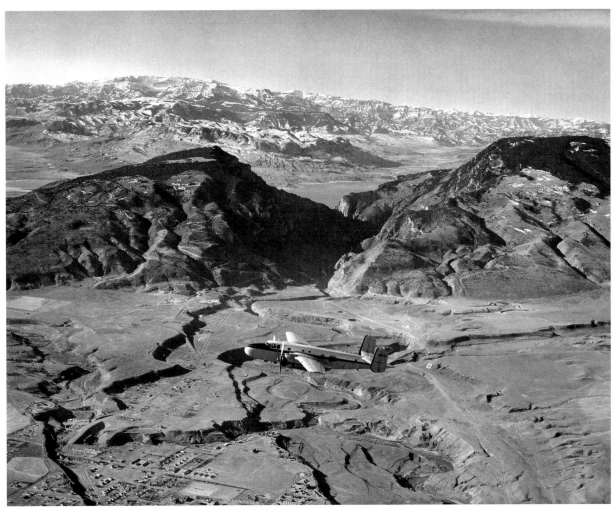

A B-25 owned by Husky Oil Company flies above Cody, with Cedar Mountain on the left and Rattlesnake Mountain on the right. Richard used this image on his business letterhead. (1957)

wheel next to his seat to adjust his vertical and horizontal trim tabs for straight and level flight. With this old-fashioned autopilot engaged, he could fly steady for a good stretch of time as he composed his picture through his viewfinder. Sometimes he charted course for a specific range or valley, timing his arrival for the pitch of sunlight and depth of shadow he sought in his picture. Many more times he thrilled to those images he chanced upon in the course of happenstance—

taking the long way home, seeking the cautious route through dangerous mountain peaks. He logged hundreds of hours of flight time this way, photographing this land he called the "Foothills to Heaven," and stretching his joy of flight across many fruitful years.

"When he was up there where the eagles soared, he could see the beauty and the vast expanse," Bob says. "He flew until he turned 80 and took pictures to the end."

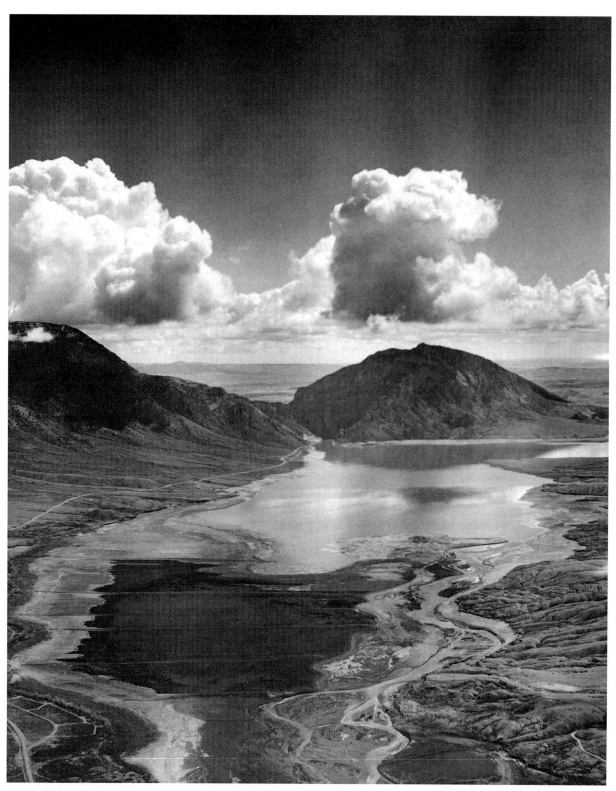

The Buffalo Bill Reservoir appears very low in this view looking towards the dam. (1961)

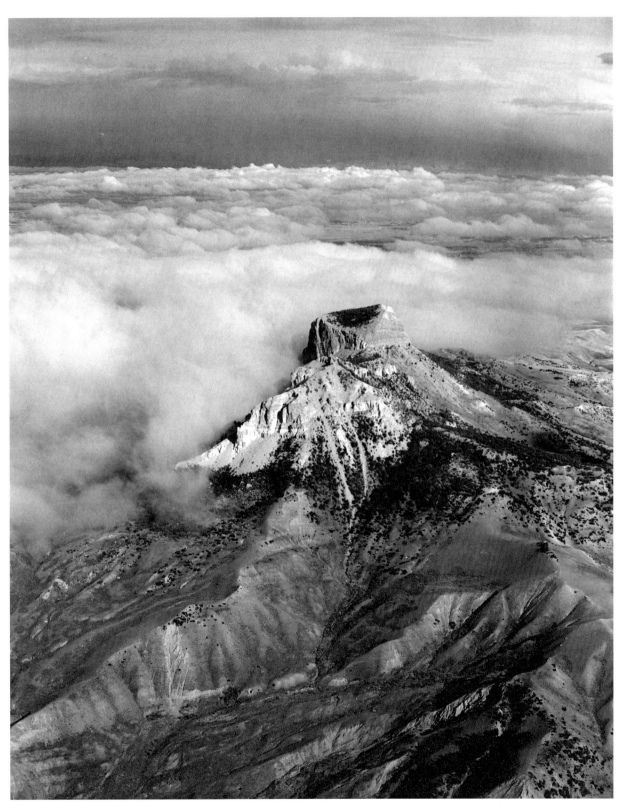

Heart Mountain, a symbol of the Big Horn Basin, is crowned in cloud cover. (1957)

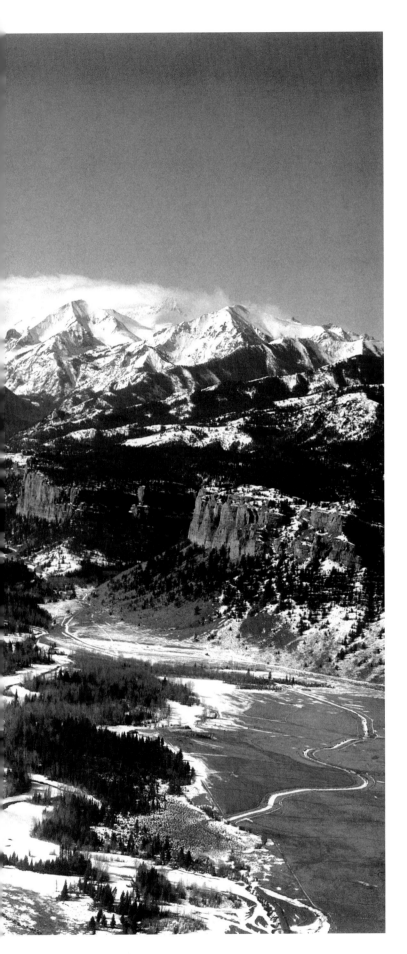

The upper Sunlight Valley, with the Bugas Ranch and 7D Ranch in the foreground. (1963)

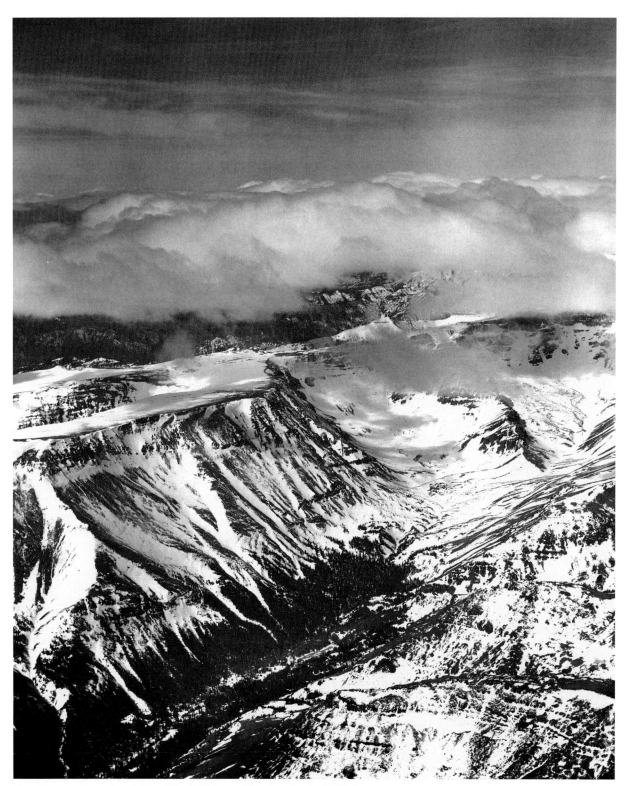

Cloud cover scrapes the peaks of Wapiti Ridge and Hardpan Basin. (1960s)

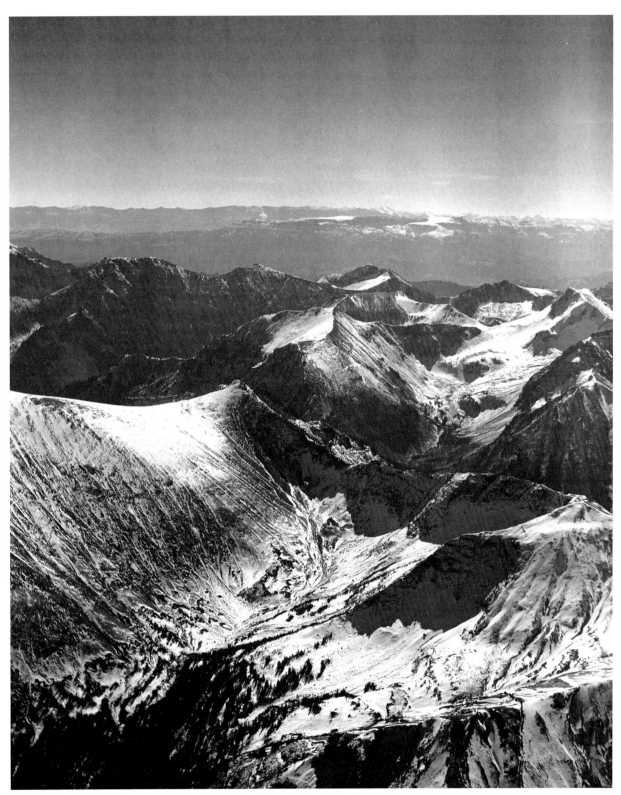

Peaks in upper Sunlight from an altitude of 13,000 feet above Galena Creek. (1957)

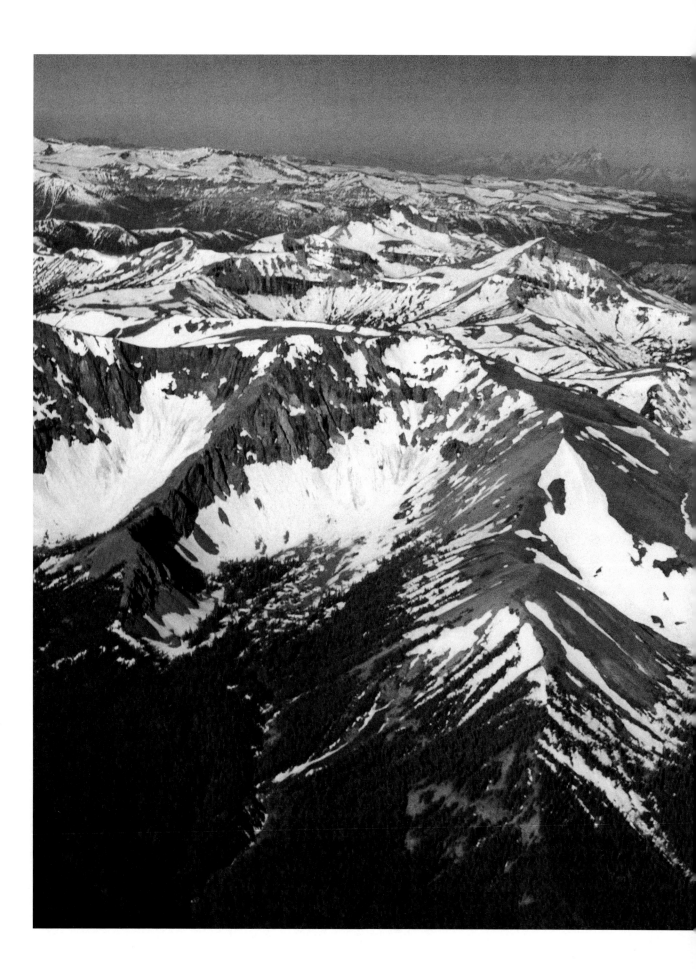

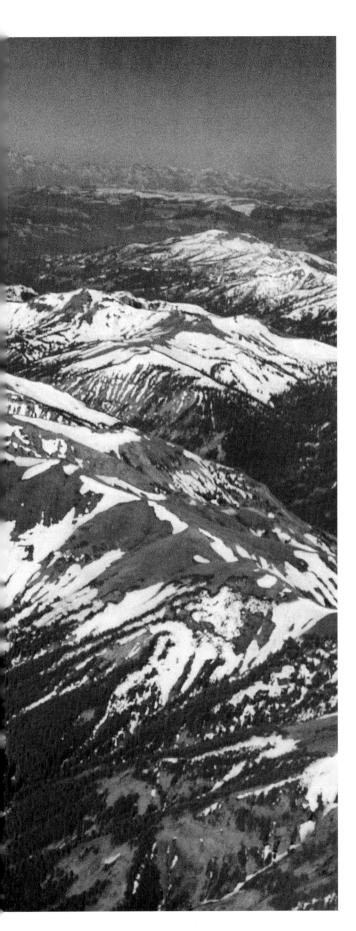

As the snow melts in the spring, the White Horse of the Ishawooa forms on the mountain. When the reins on the horse start to disappear, outdoorsmen know the trails into the Thorofare are passable. (1960)

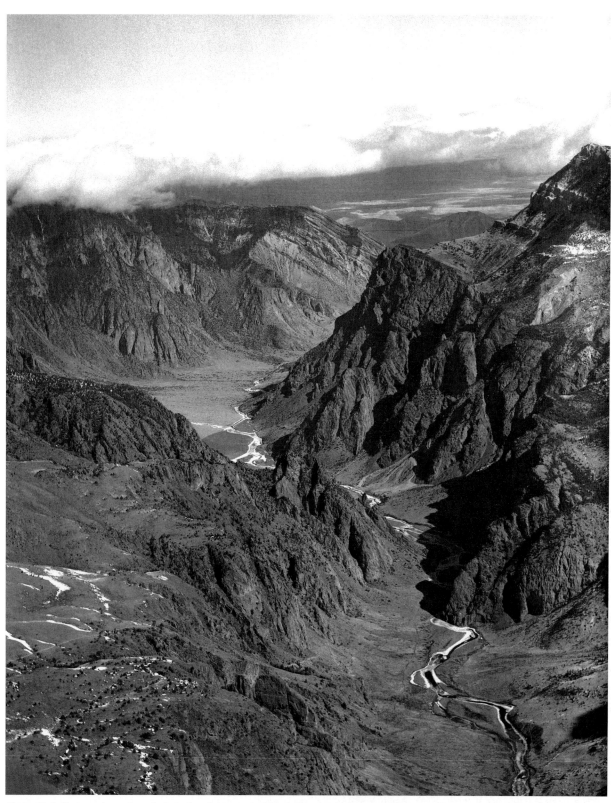

Clarks Fork Canyon rises abruptly from the plains west of Clark, Wyoming. (Early 1960s)

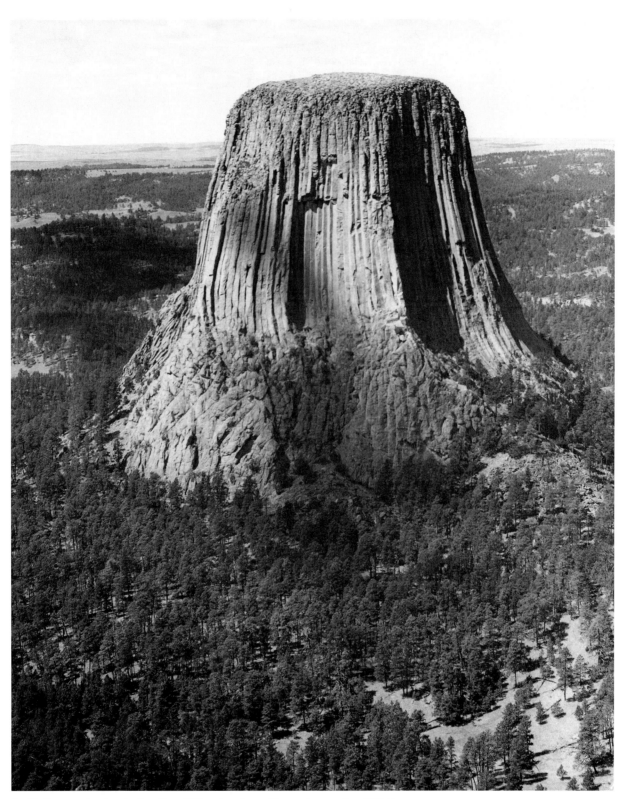

Devil's Tower, a landmark of northeast Wyoming, framed in ponderosa pine. (1964)

4.
Seasons of Wildlife

An elk with long and snow-white hair
Stood with raised head to send
A challenge, his honor to defend!
—Jack Richard, 1932

In the warm glow of sunrise spreading across the valley, a lone bull elk can be seen rubbing its antlers against young pine trees, as if strengthening its neck muscles. During an anxious moment the elk pauses to lift its magnificent head and send forth one of nature's most dramatic sounds: the challenge of the bugle echoing through the dense forest. As the echo fades, an answering challenge echoes back across the frost-touched meadows, as it has for thousands of years during the early fall, during rutting season.

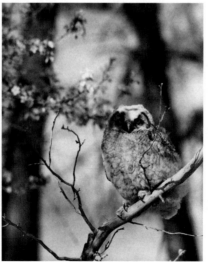

Along the course of his outing to Yellowstone that September day, Richard saw ducks and geese coasting across the ponds of Hayden Valley, a bull moose splashing through the shallows of a river and, here and there, an unhurried bison standing silent in the sage. In the moist chill in the breeze and in the denser hues of steam rising from the geysers and hot springs, he could feel the cycles of the seasons rolling through the countryside like shades of brown and burnt orange through summer's green

leaves. The elk gathered his herd, the bear dug deeper for food and the geese readied for flight. Every living thing seemed preparing for winter.

When the snowflakes fly in great sheets across the sky and accumulate in deep banks across the high country, the bison plow their stoic course against the elements and the elk and deer gather in herds for mutual protection. Coyotes, otter, mink and red squirrels, and many creatures that remained obscure during the summer, become readily visible in their quest for survival and food—leaving tracks in the snow like letters on the printed page.

"Nothing can make the heart skip or thrill the sense of beauty like topping a ridge or rounding a mountain and suddenly coming upon a band of elk moving down out of the deep snow of the high country and heading for the grassy slopes of the foothills," Richard writes. "Now they are on the move."

Following the seasons of wildlife through 82 cycles of his life, Richard awaited each with

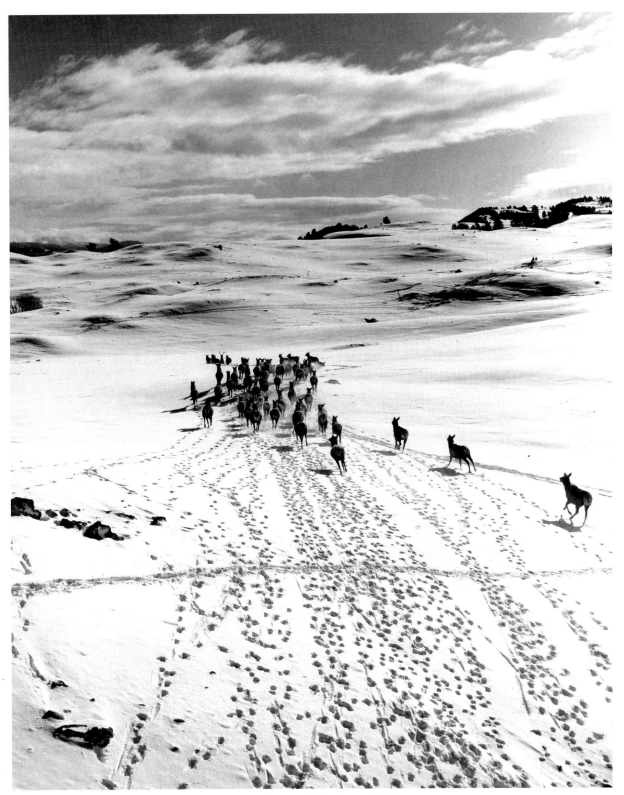

A herd of elk is on the move during the height of winter in upper Yellowstone. (1963)

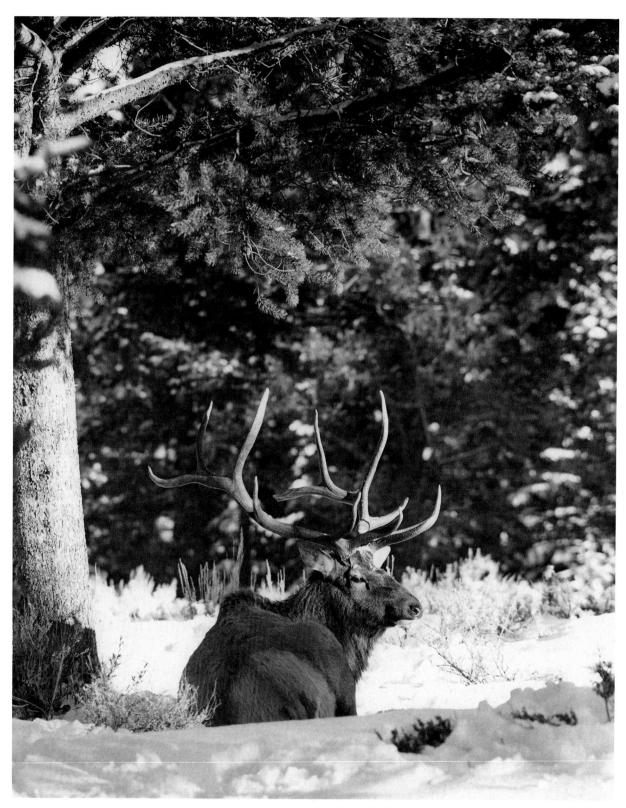

A magnificient bull elk basks in the winter sun near Yellowstone's Lava Creek. (1956)

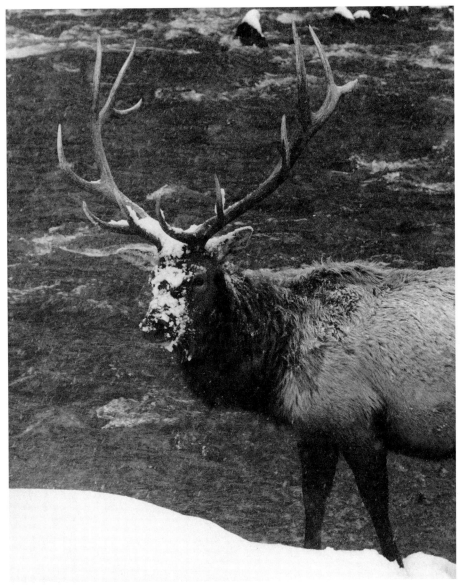

An old bull elk basks in the winter sun near Yellowstone's Firehole River. (1956)

anticipation. If autumn is the season to prepare, and winter is the season to toughen and endure, then spring is the season to refresh with joy as the world jumps with life. When the lakes and streams cast off their coats of ice in a gurgle of melting snow, the ground sparrows scurry through the brush to build nests for new mates and the trout rise for the new hatch of flies—rippling hundreds of rings across placid waters as they splash back. And Yellowstone the Lovely Lady looks to the sky and beckons to the Canada geese and streamlined blue-winged teal.

"She smiles at those of her children who spent the long, blustering winter quietly sleeping in snug dens or nests, insulated from the piercing cold by leaves and grass and deep white snow," Richard writes. "One by one they have stirred and opened their eyes, stretched their cramped muscles and moved out into their new world. The shy grizzly munches green grass, and chipmunks dart about and then sit up and chatter. The elk and deer and even the grumpy, silent buffalo, weary and weak from the long fight for survival amid deep-piled snow and lashing blasts of blizzards, gorge themselves on newborn grass and then lie down to sleep in the sunshine."

During his ventures through Yellowstone Country, Richard trained his eye on the full spectrum of

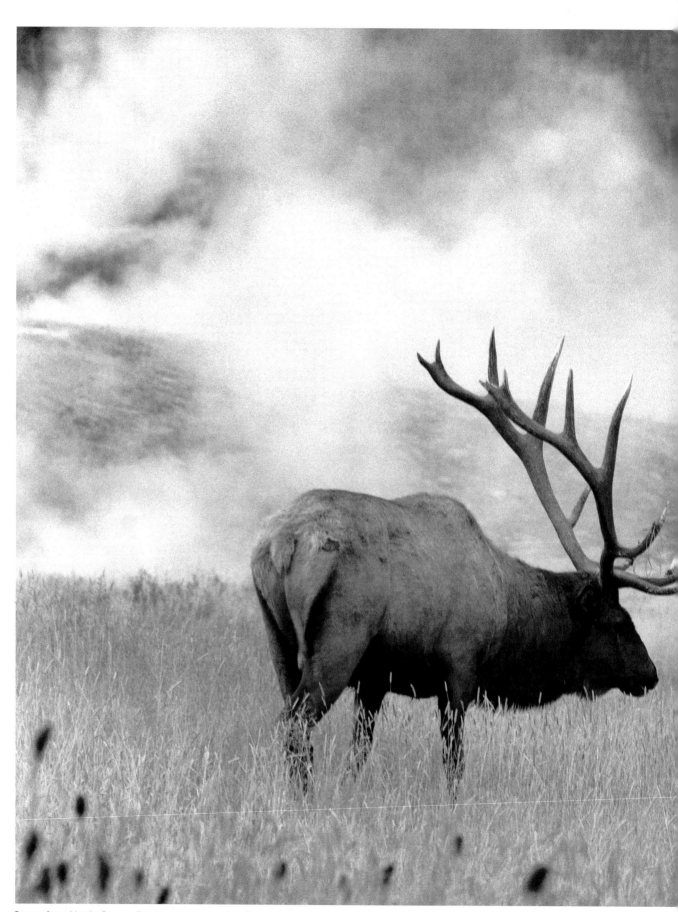

Steam from Norris Geyser Basin surrounds a bull elk in rut. (1960s)

creatures populating the natural world, giving equal measures of attention to the kings like the elk and bison as well as the little ones—the bunnies, beavers and gophers. He was especially fond of those with wings: a little bluebird on its perch, a glowering owl or a crane on a graceful landing approach to its nest.

As a human observer in tune with the natural world, and especially as a photographer on the watch for pretty or evocative pictures, Richard developed a heartwarming perspective on the wonders of wildlife which he shared through a regional freelance network extending from Livingston, Montana, to Casper and Cody, Wyoming, and *Denver Post Empire Magazine*. In additional stories, essays and letters, Richard reflected on a variety of values he saw in wildlife beyond pure aesthetics. In its interplay with humans, wildlife was a valuable resource to be managed with care.

Richard realized that human pursuits such as hunting and ranching play a big part in shaping the "natural state" of a place like Yellowstone as it's perceived at any point in time. Those big elk and deer herds so common today were more naturally animals of the plains and foothills before human populations, and grazing cattle and sheep, spread into the region and prodded them to seek higher ground. As more people entered the area, wildlife management became increasingly complex. Richard wrote dozens of articles on the subject, and he was the first reporter to cover a 1961 elk reduction program from the scene.

Promoting Yellowstone as a "wildlife sanctuary and reservoir," Richard recalled the words of President Theodore Roosevelt when he dedicated the North Gate in 1903:

"Here all the wild creatures of the old days are being preserved, and their overflow into the surrounding country means that the people of the surrounding country, so long as they see that the laws are observed by all, will be able to ensure to themselves, and to their children and to their children's children, much of the old-time pleasure of the wilderness and of the hunter in the wilderness."

As people found new ways to manage, use and develop the natural resources of Yellowstone Country, it's clear from Richard's writings and photos that its most precious resource, its wildlife, was closest to his heart.

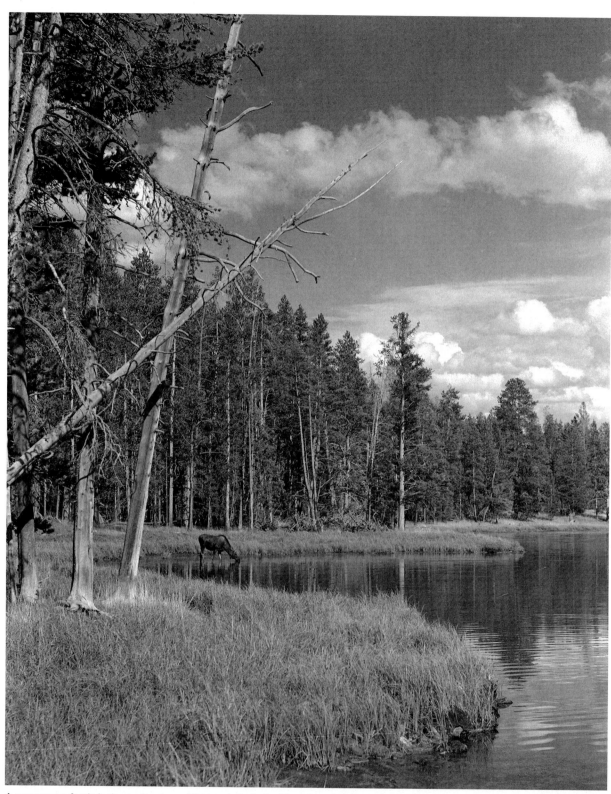

A cow moose feeds in the cool waters of Bridger Lake in the Thorofare. (1952)

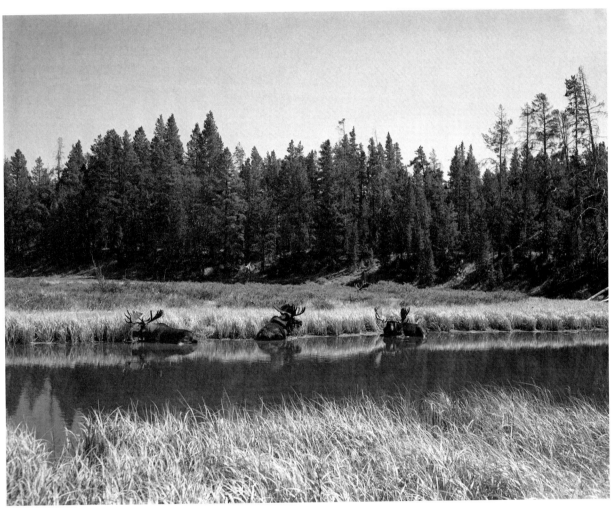

Three bull moose line the bank of Yellowstone's Pelican Creek. (1966)

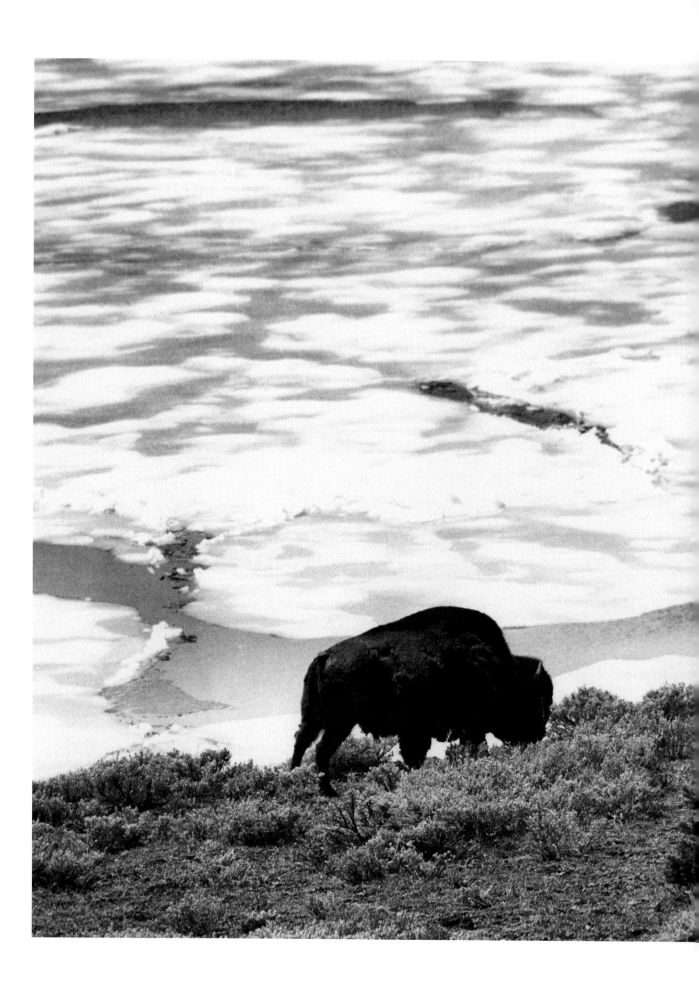

A bison feeds near Steamboat Point as a spring thaw breaks up ice on Yellowstone Lake. (1964)

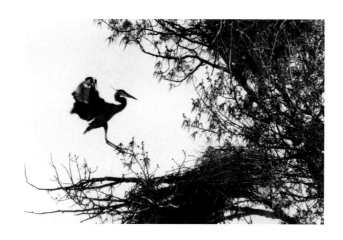

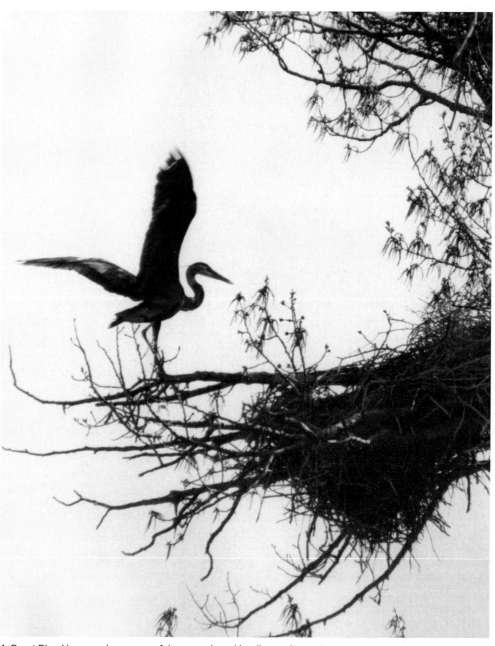

A Great Blue Heron makes a graceful approach and landing on its nest.

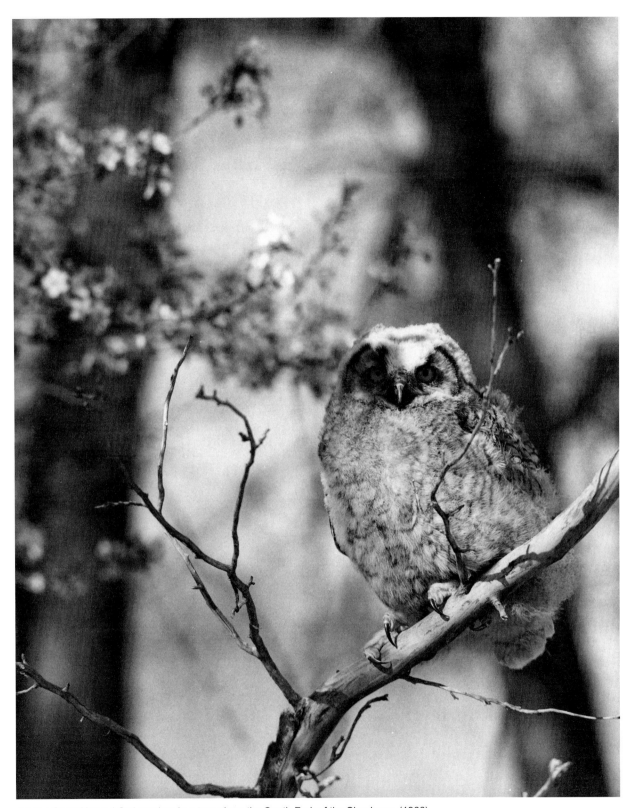

A baby Great Horned Owl perches in a tree along the South Fork of the Shoshone. (1966)

5.

Working the West

*Cody has been singularly fortunate in having had men
living here whose business ability, foresight, generosity and
community spirit have contributed substantially to the
growth and success of the entire area.*
—Jack Richard, 1950

When Jack Richard packed the tools of his trade into his canvas bags and went to work in the countryside, he imagined himself a photo assistant to a much higher artistic director. He framed his composition, adjusted his aperture and snapped his shutter on views of tumbling waterfalls and snow-covered peaks that Mother Nature had laid out for him. Even those cowboys on the range, so closely tied to their land, were players in a story line she drafted against backdrops of sweeping landscapes. Along his trail through Yellowstone Country, as if leading his packhorses from the ranch into town, Richard would explore a fresh line of images in a brand new production. Mother Nature was still in command of this scene, but some of her children had been building tools of their own and making a racket with them to scratch and probe the plains, make cuts along her cliffs and channel her waterways in a relentless pursuit of her resources.

Harry Lingelback drives a Euclid Rockwagon. (1958)

Richard spotted new artistic elements to work with on the landscapes of the 1950s. Here was a patchwork of metal pipes glistening in the late-day sun, and there was a tower rising from the plains, something like a rocky pinnacle, only forged of steel. He once imagined an oil worker would chuckle if he told him he could make a pretty picture out of an oil rig. But sure enough, as Richard would say, the darnedest things happen. His photo of an illuminated drilling rig beneath a full moon in a halo of clouds won the 1962 Picture of the Year Award from the Wyoming Press Association.

While winning his self-imposed challenge to find a good picture anywhere, the photographer who chronicled changes in the livestock industry from horsepower to engine power realized his photos of industrial progress marked another transition. This was a transition engineered by "a generation of people destined to bridge the fading Old West to

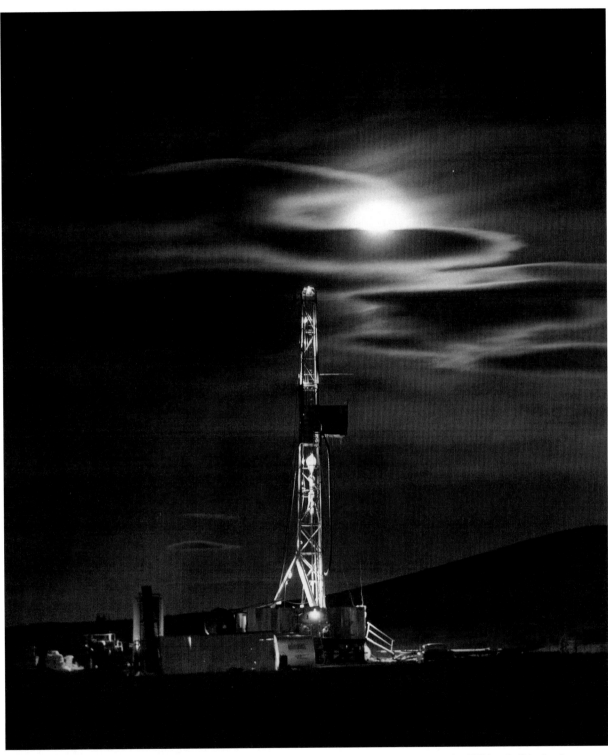

Moonlight illuminates a Husky Oil drilling rig in Oregon Basin. The Wyoming Press Association judged Richard's "Magic of Moonlight" the best weekly newspaper photo of 1962.

the beginning of a new and brilliant era of science and technology." As he gazed down on a new addition to Husky Refinery, the array of pipes and tanks reminded him of a launching pad at Cape Canaveral. In the boundless and adventurous optimism of the Fifties, not even the sky was the limit of human aspirations.

In these snapshots of human history, Richard saw more than the high-tech structures of his times. What excited him most about his changing times was the spirit of the men and women of his generation. As they set new records for the deepest oil well or the longest tunnel, these businessmen and workers of the new frontier carried on the vision and ambition their forefathers blazed on the old frontier. In captions he wrote to describe his pictures of industrial marvels, and in further editorials and stories, Richard describes the pioneers behind the expansion as people of "rugged individualism and dogged determination," leading the way toward success and progress. In some ways, he appeared swept up in the glow of "boosterism" that commonly flows through promotional writings about this subsidiary of Yellowstone Country known more closely as Cody Country. Yet Richard was a newspaperman, with printer's ink flowing through his blood, and one can only imagine he chose words like "determination" and "individualism" with the same caution and precision he used to choose all his words as a journalist.

What word other than "visionary" could he use to describe those who imagined, planned and engineered a scheme to bore the longest highway tunnel in Wyoming through more than 3,000 feet of sheer granite along the course of a dangerously steep canyon. What words other than "rugged determination" could he use to describe the force and drama in the face of a hard-rock miner chiseling with his drill the final few inches of the 8x8 foot pilot tunnel to a crack of light on the other side. After all, a man could be seriously hurt or killed in this effort. And many were hurt, and one was killed.

And what word other than "progress" could he use to describe this effort to tame, once and for all, this impossibly steep and rugged box canyon, replacing a twisty, bumpy, hilly old road with a smooth, gently curved modern highway that would sweep thousands, ultimately millions, of motorists along the

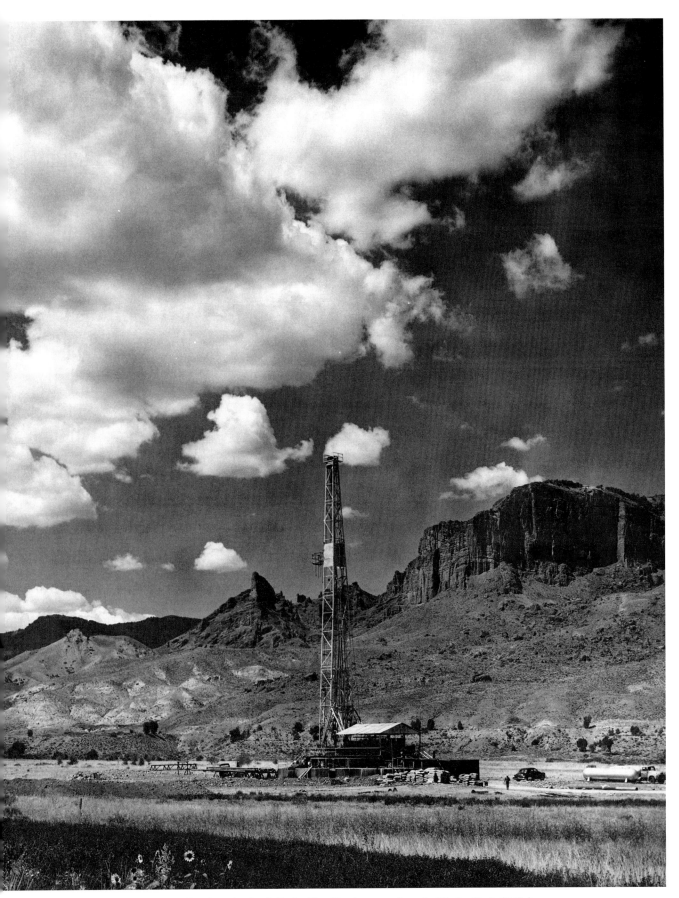

A Husky rig drills for oil on the South Fork of the Shoshone southwest of Cody. (Early 1970s)

tourist corridor from Cody to Yellowstone Park. Certainly the town of Cody, and all of Cody Country, felt justifiable pride when Governor Jack Gage attended the 1961 dedication ceremony and threw the "official switch" to engage the tunnel's interior lighting system. If the state highway department hadn't provided resources to build this tunnel, the governor told the assembly, he was sure "the people of Cody would have dug it by hand."

In the uplifting spirit of the 1950s, it seemed men everywhere were busy taming nature—boring holes through the mountains with a huge hydraulic machine called a "Jumbo," directing a great river through new channels and tunnels to better serve an electric power plant and a sprawling irrigation network, and venturing "like an ambitious young man" to ever higher and rougher terrain in search of new fields of oil to flow through the "life blood line" of Cody Country. As he pounded out copy on his typewriter and hustled out the door with his camera, it seemed Richard could barely keep pace with developments that kept his hometown bursting with pride.

During the 1940s, the Husky Oil Company had more than doubled its annual sales, and by 1950, with Glenn Nielson at the helm, the company marked its most successful year since its humble beginnings in 1938. The community commemorated the company's success with "Oil Progress Week," and adopted the theme "Your Progress and Oil Progress Go Hand in Hand." Among the guests and assembled dignitaries at a highly publicized dinner-dance was "Miss Oil Progress of Montana-Wyoming," who was "brought to Cody by airplane specially for the occasion."

In the isolated, rugged and rural environment of Cody Country, almost every modern improvement seemed to inspire a story of vision and determination—even the placement of a television

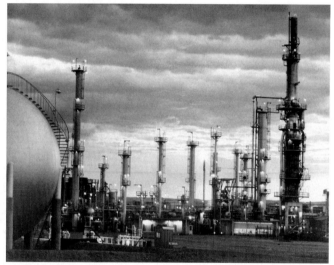

The Husky Oil Refinery north of Cody has since been dismantled. (Circa 1960)

transmitter. As envisioned by Cody Community Television, this transmitter high atop Carter Mountain would catch a "live network signal" broadcast from 175 miles away in Idaho Falls and feed it to television sets in Cody homes. With a flick of the wrist, television viewers could tune in the big stars such as Red Skelton and Eddie Cantor and new sitcoms such as *Life with Elizabeth*, starring Betty White as an "inquisitive wife tangling her husband in knots."

In a 1957 editorial in the *Cody Enterprise*, Richard writes, "When a television user flicks his wrist and changes channels, none, by this simple motion, releases at his command the rugged individualism, the dogged determination and the vision of the future that belongs to Cody's Able Cable enjoyers. For no place in these United States have the TV signals been captured, transformed into microwaves and rebeamed under such trying and adverse conditions as those from Station KID-TV."

Richard had reason to boast on the company's behalf because he had flown into the "world's tallest antenna site" at 11,290 feet on Carter Mountain to photograph a mission to repair a damaged diesel engine. Not only was the transmission site the highest in the country, so too was the landing strip used to access it.

"We settled into a postage stamp airstrip clinging to a narrow ledge far above timberline and just below the antenna site," Richard writes. "The approach is over a deep ravine; the 1,200 feet of the airstrip is high on both ends, low in the middle, and at the far end spills off into a gigantic field of volcanic eroded needles."

The placement of this TV transmitter was indeed a heroic feat, judging by Richard's recollection of its history.

"The long hours of trudging over mountains to find the best available TV signals, the bulldozer-constructed

82

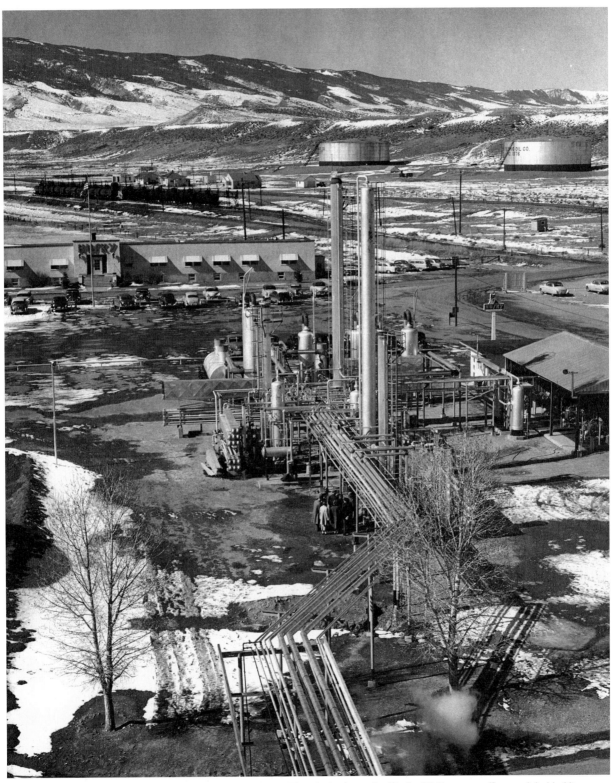

Cody people tour the latest improvements to Husky Refinery. The photo shows the Husky Oil Company office, and, behind it, Marathon Oil's crude oil tank car loading facility. (Circa 1953)

fair weather road up from the flatlands, the daily trips, for months on end, with four-wheel powered vehicles, the material for construction of two buildings, the diesel-fed power unit and generator, the cement cookers, toothpaste and 2,500 gallons of fuel, the cook stove and air speed indicator (which has measured the fresh air moving by at speeds in excess of 100 mph) all came up the hard way, 72 miles over a circuitous, grinding path of a road south from Cody to Meeteetse, west to the 91 Ranch and north up the sheer face of the mountain."

Through his scenic and wildlife photography, Richard had captured many views that were important to his sense of artistry and history. As a newspaper and portrait photographer, he would focus more closely on television pioneers such as Brick Melbraaten and Harry Moore and a long parade of Cody Country people and personalities who had tailored their lands and their times.

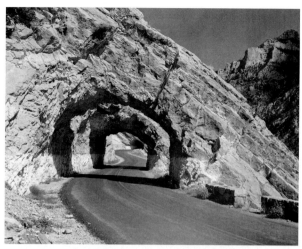

Two smaller tunnels west of the main tunnel along the Shoshone Canyon on the North Fork Highway from Cody to Yellowstone Park. (1957)

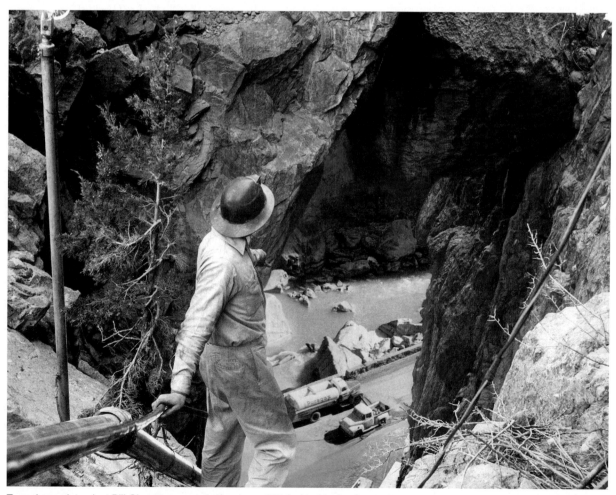

Tunnel superintendent Bill Gianetto pauses halfway up a 500-foot ladder leading to the east portal of a 3,276-foot pilot tunnel through Rattlesnake Mountain. (1957)

84

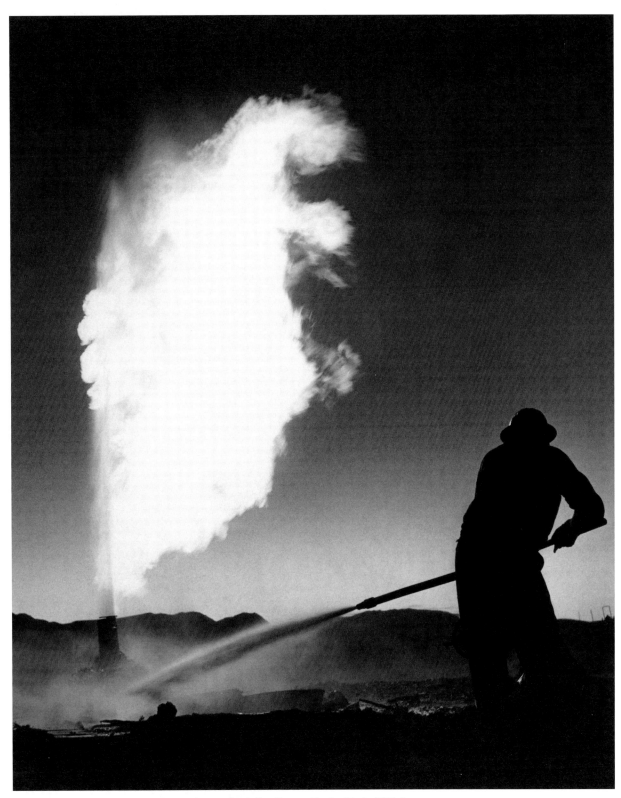

A firefighter aims his hose at the base of a gas fire in the Oregon Basin. (Early 1950s)

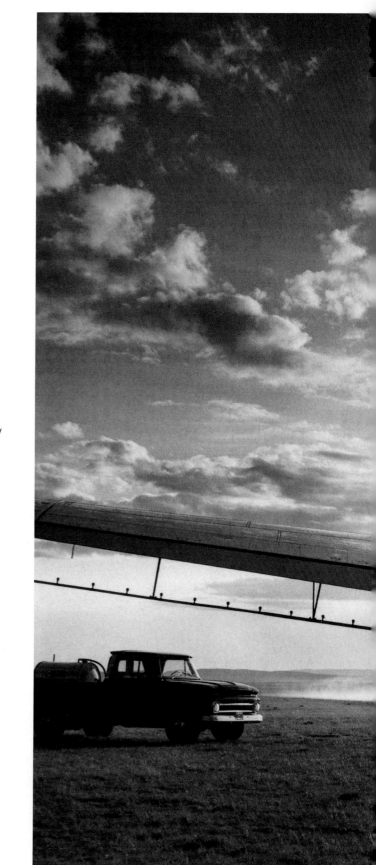

Mel Christler's DC-3 rests while a Cessna Aero Flight owned by the Elgins makes a run. (1965)

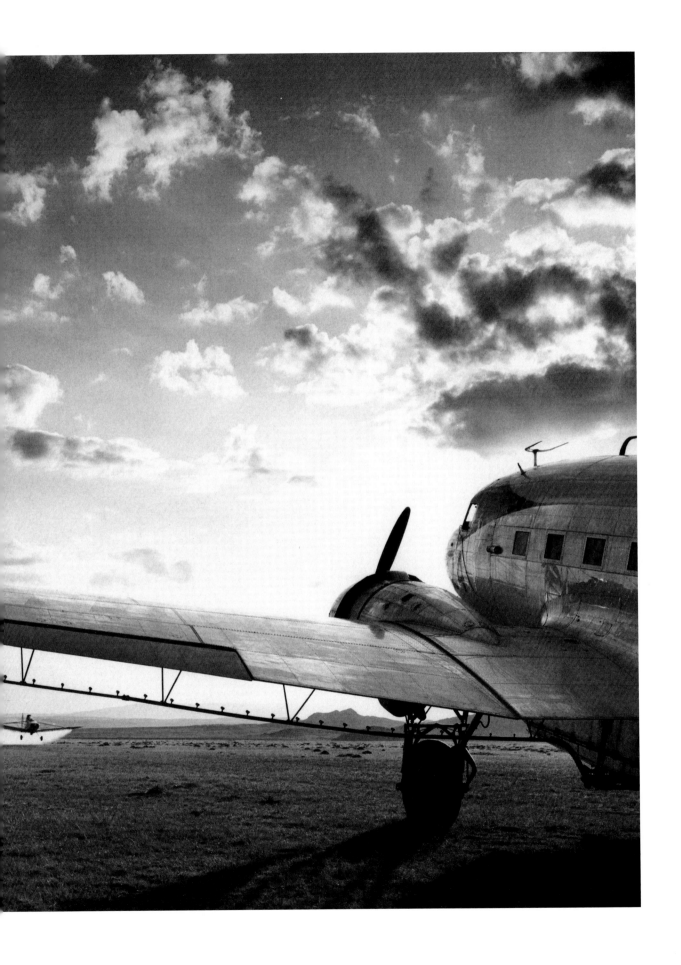

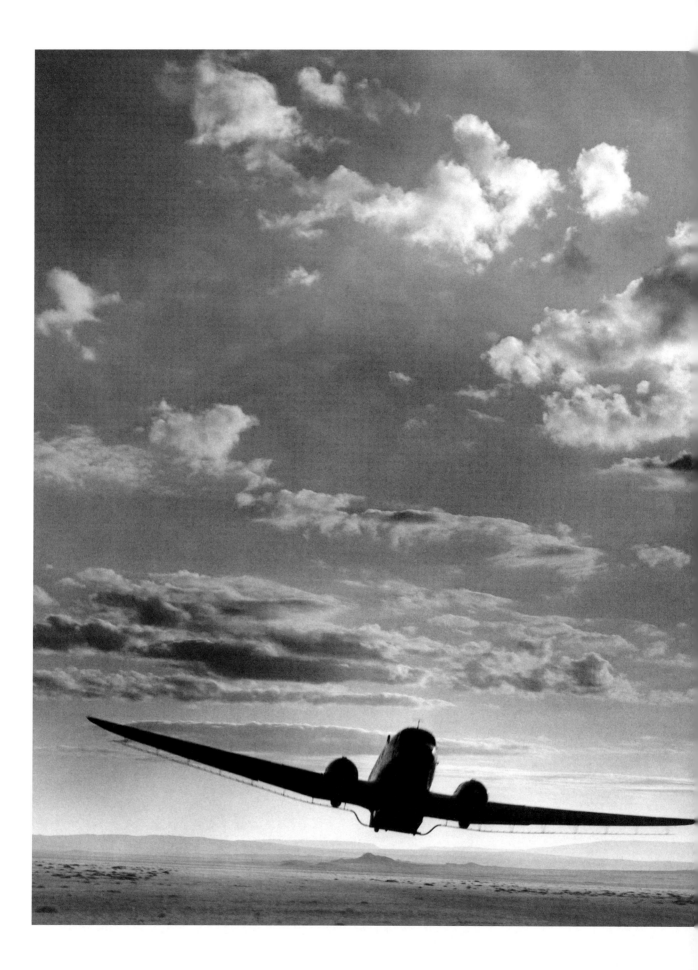

The converted DC-3 takes off from an airstrip to spray sagebrush north of Cody at dawn. (1965)

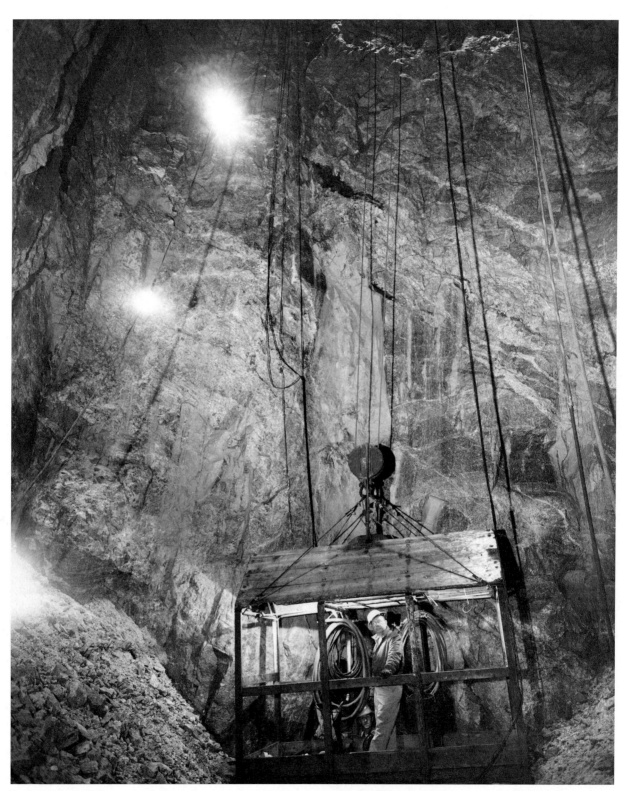

Engineer Hugh Whitmore stands in an elevator cage along the canyon at Buffalo Bill Dam. (1958)

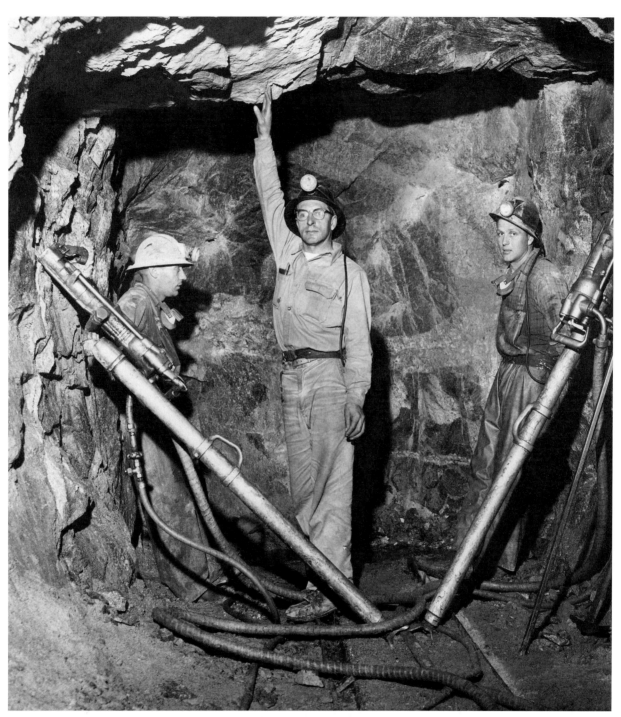

A supervisor touches the top of a new spillway being bored at Buffalo Bill Dam. (1958)

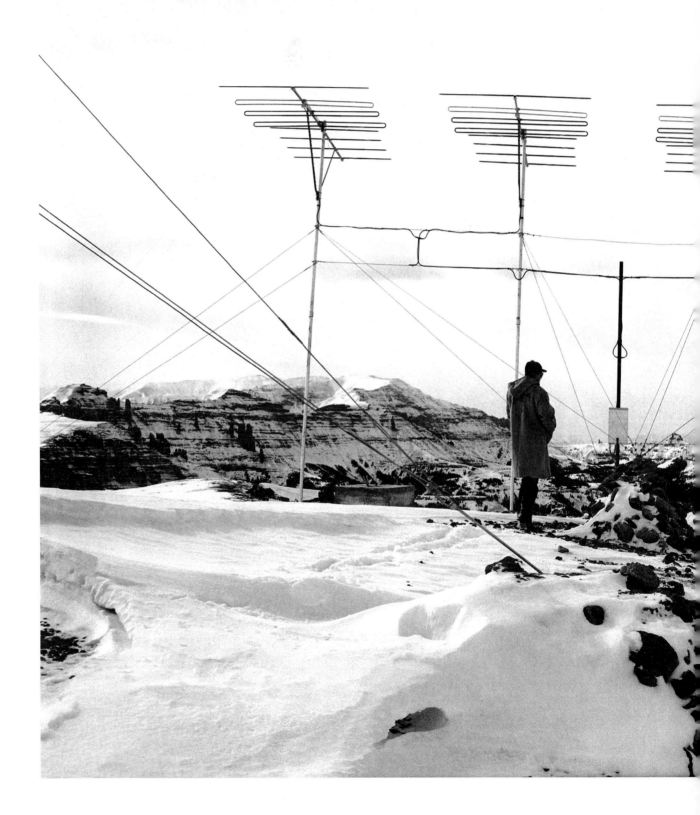

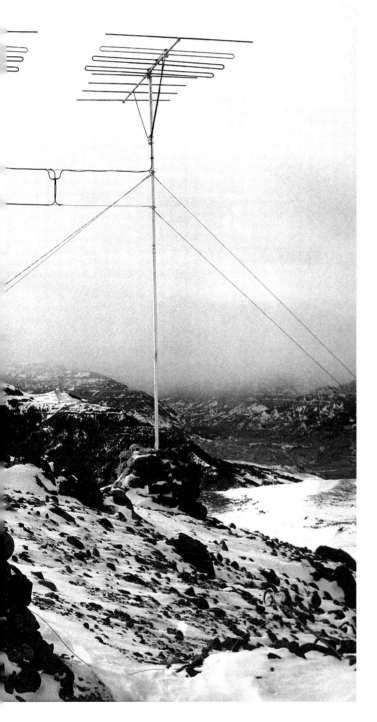

A lone figure stands at the Cody Community TV transmitter site atop Carter Mountain. (1958)

6.

Signs of
the Times

Clap your hands, I'm going West,
Going home for home is best.
I have leave and back I go,
Thinking some and humming low.
—Jack Richard, 1932

For more than twenty years, Jack Richard delivered his latest batch of photos in the form of a weekly newspaper rolled up, secured with a rubber band, stuffed into bags and launched by newspaper boys to twirl up steps of front porches and slap front doors of homes all across Cody. Week by week and year by year, the constant tempo of newspaper deadlines prompted a relentless production of photos that accumulated into a Jack Richard Collection of more than 160,000 images. While feeding the sheer volume of his collection, his work as a news photographer added to the remarkable variety of his subjects— from the serene mountain range to the main street of a city bustling with its annual Stampede Parade. As Richard scoured his hometown streets for this line of cityscapes, he came to know his own hometown as few people can.

In the datelines of his life, one can trace a course of printer's ink in his blood to the year 1931 when he first joined the *Cody Enterprise*, fresh from college at the age of 22. Peter Wilson says he started as an

Former Governor and Senator
Cliff Hansen

advertising salesman and then branched into news writing as a cub reporter. Mostly he wanted to tell stories—the same way he told stories to guests around the campfire as a backcountry guide. He had little interest in photography until he left Cody for a newspaper job in Sheridan. In his own memoirs, Richard recalls the very day he caught the camera bug.

"My photographic career began very suddenly in June, 1937, while I was city editor of the *Sheridan Press*," Richard writes. "There had been a multi-death auto accident in the area and the editor came in, camera in hand. He told me he had heard that I could see a deceased person without getting sick. When I nodded, he handed me that camera and sent me out. The photos I took that day appeared in the *Press,* and my photojournalism career was launched."

By the age of 31, when he went to Colorado for a job with the *Grand Junction Daily Sentinel,* Richard still preferred writing news stories. But he was keeping the camera closer at hand and learning how to package his writing with pictures. After a

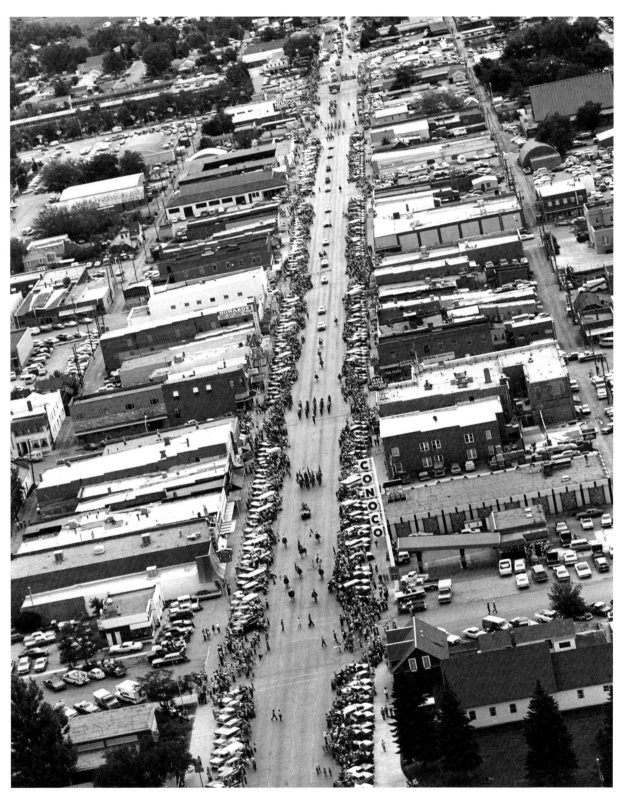

The annual Cody Stampede Parade marches west on Sheridan Avenue. (Late 1950s)

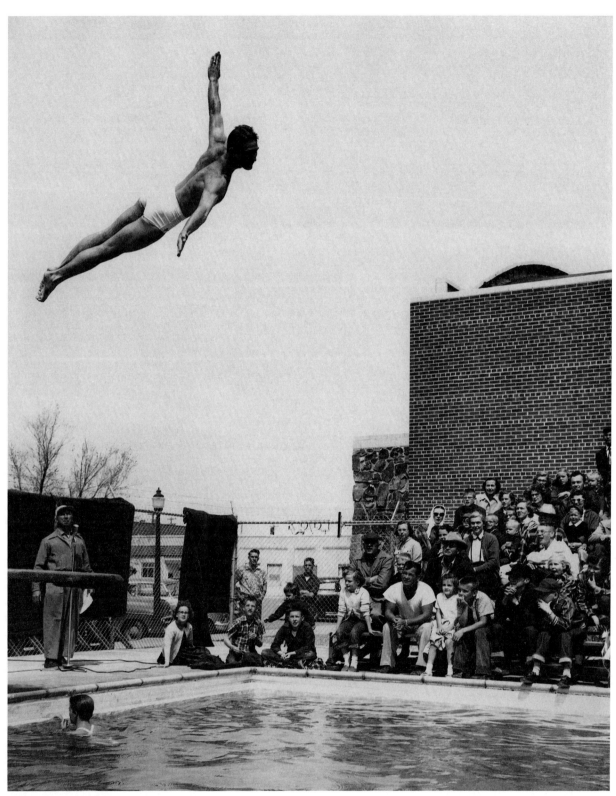

Merrill Hodges exhibits his diving skills at the opening of Cody's outdoor pool. (1954)

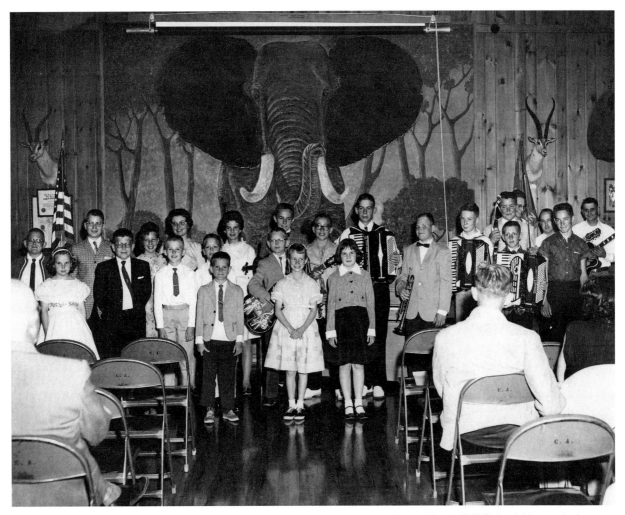

Students perform a music recital in the Cody Club Room before a backdrop painted by taxidermist Will Richard. He attached ears from an elephant he hunted on an African safari. (1963)

short stay in Colorado, Richard returned to Cody in 1941 with plans to plant his roots and stabilize his career by leasing the *Enterprise* and becoming its editor and manager. Then war broke out and interrupted everything. Like many volunteers, he was suddenly packing his bags again—this time for the South Pacific at the age of 33. Leaving his wife, Rhea, in charge of the paper at home, Richard was off to basic training and to serve his country and the Marine Corps as an air intelligence officer.

Nearing the end of the war, Richard was charting his course back home when a twist of fate steered him off to the nation's capital. At the time, according to Richard's son Bob, Congress was considering merging the separate branches of the military into one unified armed force. Senator E. V. Robertson, a Cody native, wanted a man on his staff

who believed, as he did, that the branches should remain separate. Richard fit the bill and filled the role as the senator's chief of staff for three years. During his tenure, Richard became well-acquainted with Wyoming's political base, developing contacts he would maintain throughout his life. Along the way, he gathered new skills and learned much about himself. One lesson he learned was that he didn't care for government bureaucracy or big-city life. At the age of 38, he headed home to start a new enterprise.

"He would always say that Cody is home," his son Bob recalls. "He would say Cody is where our friends are, and Cody is where we have always wanted to live."

Like many men returning home from the war, even after a three-year sidestep, Richard would

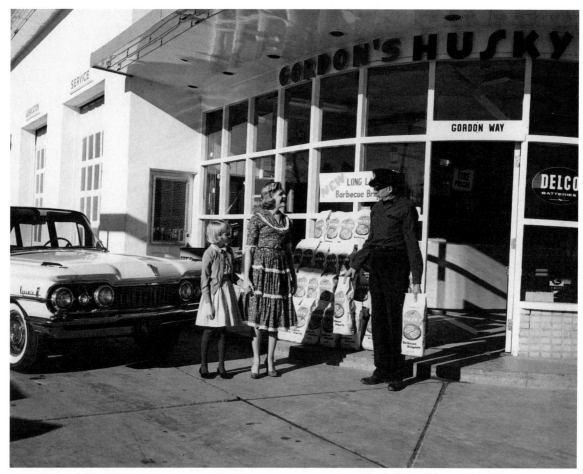

Service station owner Gordon Way poses with customers for an ad photo featuring Husky Oil Company's new product, barbecue briquettes. (1960s)

start a business. Like many such businesses, this one had humble beginnings. Partnering with his cousin Jess Frost, Richard launched a newspaper to rival the cross-town *Cody Enterprise*. On January 6, 1947, a mimeographed sheet came "rolling off the press" in the basement of Richard's home a block off main street. Richard sold advertisements for those early editions of the paper that he published with assistance from his wife and son. But those early subscriptions were free—and delivered door to door by young Bob and a squadron of friends.

For the next several years, through the pages of his *Cody Times*, Richard pioneered a fresh treatment for the use of photographs in Wyoming newspapers and started a legacy of excellence that would attract dozens of awards from state and national newspaper associations. Unlike most papers, this was a tabloid with a vertical shape instead of the more usual broadsheet. And Richard took full advantage of each edition by blowing up

his best photo to fill the cover. He often enlarged his horizontal photos across the front and back of the paper, so the newspaper reader had only to lift off the top sheet, and open it across a table to see the full view.

When *The Cody Times* and *Cody Enterprise* merged under joint management, the *Enterprise* continued what Richard started by publishing a weekly pictorial edition along with the standard broadsheet paper. The pictorial edition, called the *Lariat* for a number of years, continued to carry Richard's weekly front-page picture and tons more inside. When he took another career step to start his own photo studio in 1952, he continued to work as the newspaper's photographer, contributing a steady steam of photos through the 1950s and most of the 1960s.

A generation of Cody people grew up on this steady diet of Jack Richard photos, and Richard kept them coming with his coverage of developments across town—from the continuing

Mrs. R. S. Allen looks up at her son Sammy in the lobby of Shoshone First National Bank. (1959)

Fred Garlow shows a colt to Karen Anderson and her husband at Absaroka Lodge. (1960s)

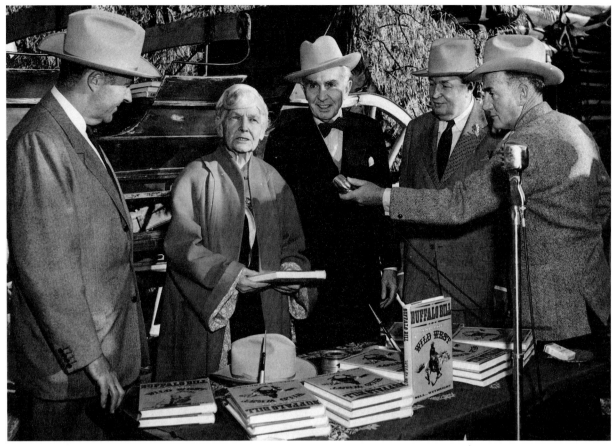

Buffalo Bill Museum Curator Mary Jester Allen accepts the first autographed copy of *Buffalo Bill and the Wild West*. An NBC reporter covered the debut of the book in Cody. (1955)

expansion of the Buffalo Bill Historical Center to the dedication of the town's first outdoor swimming pool and a campaign swing through Cody by a young Bob Dole. Richard was there in 1966 when Cody housewives teamed up to bake homemade cookies for soldiers in Vietnam, and he was still there into the 1970s when he photographed First Lady Pat Nixon's visit to Yellowstone Park. As the years went on, Richard focused more attention on his studio, and the *Enterprise* ran fewer of his photos, but his credit line still popped up from time to time.

As a consequence of his newspaper work, Richard forged the beginnings of a long-lasting partnership with his hometown. He was anxious to find his next photo for the front page, and the town was anxious to help him find it. It was not unusual to be driving down a Cody street one day and spot Jack up in the air hanging from a basket with his

camera pointed down on some statue or building. To reach the one angle he needed to catch that one precise view, he would ring up City Hall and ask them to send the cherry picker over. The city would oblige, sending the equipment and an operator so Jack could get his shot.

Unlike a typically harried newspaperman, darting about in a rush to his next assignment, Richard is remembered in Cody as a patient gentleman who always lingered long enough for a visit at the post office. Through his newspaper work, and through his photos, the town was getting to know Jack as well as Jack was getting to know his town.

"They got to know his sense of patriotism, his sense of church, his caring attitude for others," Bob says. "They got to know that he cared about this country, and this community, as much as anybody could, and that he wanted to preserve what he saw for the future—for others to enjoy too."

101

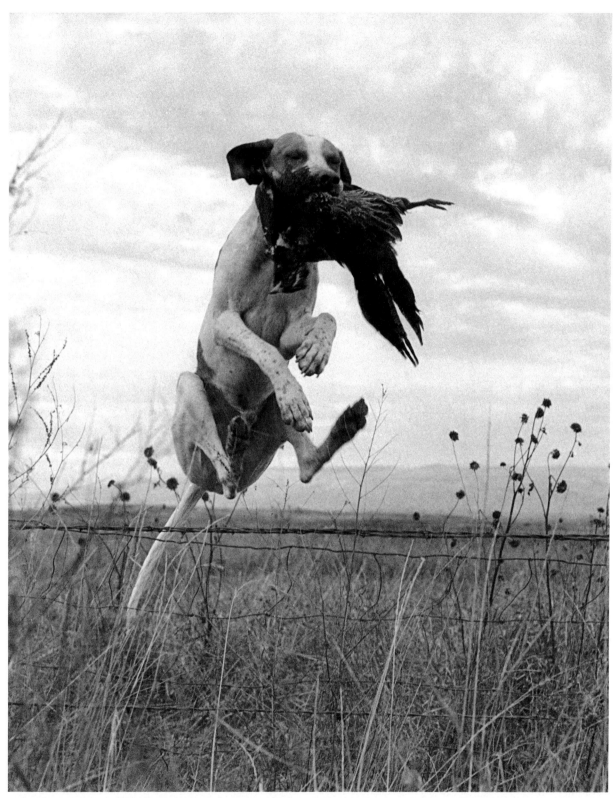

Richard's best-known photo shows a retriever leaping over a fence with a bird in its mouth. The photo made the cover of *Sports Afield* and appeared in many national magazines. (Circa 1940)

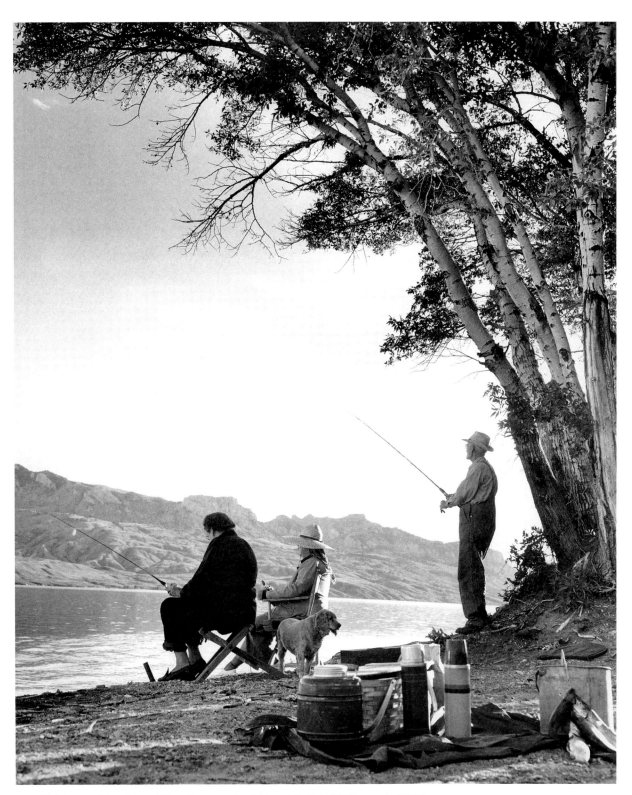

Lars Christensen, his wife, and Opal Caesar enjoy fishing at Buffalo Bill Reservoir. (1951)

A crowd turns out to open the Buffalo Bill Museum as the second wing of the Buffalo Bill Historical Center. The wing was added to the Whitney Gallery of Western Art. (1969)

Fred Garlow (standing), the grandson of Buffalo Bill Cody, appears with Wyoming Governor Cliff Hansen and his wife Martha at the 1965 Buffalo Bill Birthday party.

Left: Bob Dole (right) accepts a "GOP elephant" brand from Wyoming Congressman John Wold during a campaign swing through Cody. (Circa 1960)

Below: First Lady Pat Nixon walks the boardwalk at Old Faithful with Yellowstone Superintendent Jack Anderson and Interior Secretary Rogers Morton (left) during a 1972 visit to Yellowstone Park.

Ray Elgin accepts a thermos of coffee and some cookies from Hazel Gould (right) and Katie Brown. When Marine Col. Ray Gould made a plea for cookies for his American Seabees in Vietnam, a contingent of Cody women produced more than 2,000 two-pound tins of homemade cookies. Elgin flew the cookies to Cheyenne in his World War II bomber-slurry plane and they were transferred and shipped to Vietnam. (1966)

Before a crowd of onlookers at Cody Auditorium, Jerry Cain of the 101st Airborne receives the Distinguished Service Cross and the Purple Heart for extraordinary heroism in Vietnam. (1968)

Capt. Chip Richard (right), wearing an original Cavalry uniform, joins Sgt. Rich Fink at Old Trail Town in Cody for a recruitment publicity photo for the Wyoming National Guard. (1976)

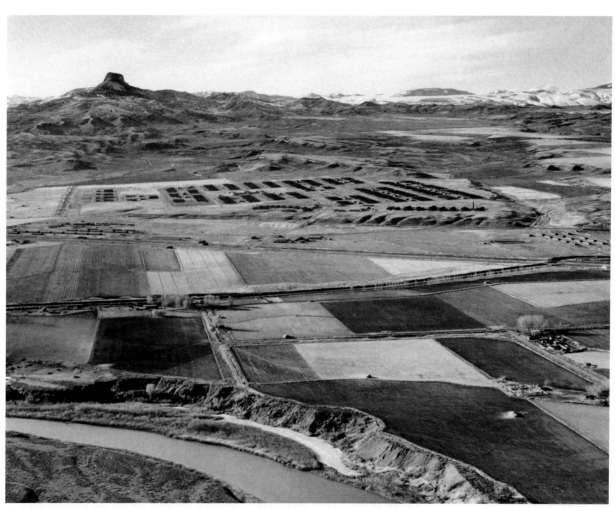

The Heart Mountain Relocation Center rises from the flats below Heart Mountain. (1942)

7.
Heart Mountain Memories

*One of Richard's most moving sets
of photojournalistic records was made
early in the Second World War.*
—Paul Fees, former curator, Buffalo Bill Museum

Jack Richard had been working as the editor and manager of the *Cody Enterprise* for about a year when the most important story of his newspaper career unfolded about 15 miles northeast of town amidst the patchwork of irrigated farmland at the base of Heart Mountain. Within a span of 62 days, a workforce of 3,000 men converged from across the region on this square-mile of loose and dusty soil to erect 468 barracks and dozens of support structures as an internment camp for more than 10,000 Japanese-Americans during World War II. While reporting this story to expectant newspaper readers, Richard also published compelling photos of this bewildering place he called "the city that was not a city."

Richard's pictures of the Heart Mountain Relocation Center have historic importance because they present rare views of the assembled workforce, the rapid-fire construction of wooden shelters erupting from the plains, the arrival of internees from the West Coast and portrayals of camp life spanning an emotional spectrum from stark loneliness to sheer joy on the faces of reunited relatives.

As a photojournalist covering a breaking news story in that fateful summer of 1942, Richard documented the camp from the beginning of construction on June 8 through the arrival of the

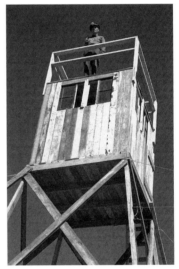

A guard mans one of nine towers. (1942)

first internees on August 12. But his photographic trail was interrupted when he enlisted in the Marine Corps and departed for basic training and eventually the South Pacific. He would return to Cody during a brief homecoming on military leave to produce some of his most remarkable photos. One can only imagine the irony he felt as he composed portraits of young Japanese-American men who had also "come home" on military leave. These Japanese-American soldiers visited their wives, sons and daughters behind barbed wire fences in the shadow of guard towers.

Like many people in the Big Horn Basin, Richard developed misgivings about the internment camp. He believed the internees were good people and understood they were Americans who were unfairly displaced. Although his experience with Heart

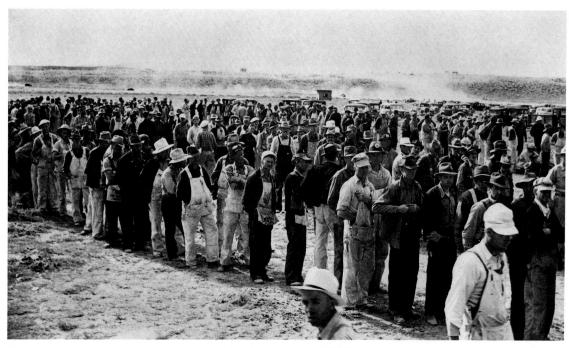
Workers from across the Big Horn Basin gathered to build the camp. (1942)

Mountain was short-lived, he got to know several internees, as did many people in Cody and Powell through work programs, business dealings and sports contests.

One of these professional associations brought Richard together with Bill Hosokawa—a young Japanese-American who was pursuing his own career in journalism when war broke out. Hosokawa, a native of Seattle and a 1937 graduate of the University of Washington, was one of almost 120,000 people of Japanese ancestry who were removed from their West Coast homes and relocated to internment camps such as the one rising at Heart Mountain.

Shortly after Hosokawa arrived at the camp with his wife and young son, the camp's information officer, Vaughn Bonnie Mechau, learned of Hosokawa's newspaper background and appointed him the editor of a weekly camp newspaper. He introduced Hosokawa to Richard so the two could work out the details of a contract to have the *Heart Mountain Sentinel* printed at the *Cody Enterprise* plant. Richard and Hosokawa worked well together, and Richard eventually hired a skilled printer and linotype operator from the camp to work on the *Enterprise*.

"In addition to editing the *Enterprise*, supervising the print shop and taking care of business, Jack was a photographer," Hosokawa recalls. "I rather think he

was more interested in photography than the other responsibilities. So he hung around the camp, especially in the early days, shooting pictures."

After Richard went to war, his wife, Rhea, took the helm as editor of the *Enterprise* and continued to print the *Sentinel* on the *Enterprise* press. Hosokowa was confined at Heart Mountain for 14 months, serving as editor of the *Sentinel* until he was allowed to leave for a newspaper job in Des Moines, Iowa. In 1946 he moved to Denver to take a job with *The Denver Post*, where he remained for 37 years, including his last seven years as editorial page editor. He taught journalism briefly at the University of Wyoming and retired after eight years as ombudsman at the *Rocky Mountain News*.

Hosokawa retains vivid memories of the day in May 1942 when he and his wife and son were locked up with about 8,000 other Japanese-Americans in a temporary camp on the fairgrounds in Puyallup, Washington. By August, he and his family were sent by train to Billings, Montana, and south to the Heart Mountain Relocation Center.

"Heart Mountain was then still under construction," Hosokawa recalls. "It was a beehive of activity with scores of carpenters building barracks, others laying sewer and water pipe, electricians stringing wire, all under a pall of gray alkaline dust. There were about 125 Japanese-Americans from the Pomona camp in California already on the site. They

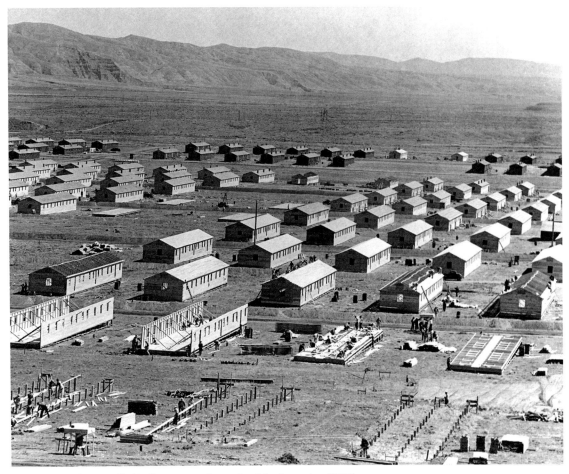

Tarpaper was later applied to the raw wooden walls of the barracks. (1942)

were members of an advance party sent to prepare the camp for those who would come later—sweeping the dust out of the barracks, distributing iron cots, getting the mess halls operating."

Hundreds of men had been recruited from across the Big Horn Basin as carpenters, plumbers, electricians and bulldozer operators to erect the bare-boned structures. The large barracks were divided into six one-room cubicles, with each room intended for one family. The raw wooden walls were later sheathed with black tarpaper to provide some protection, scant as it was, from wind, cold and dust. Each unit was heated by a potbellied stove. Smaller buildings were built as mess halls and as combined restrooms, showers and laundries—each equipped with a coal-fired boiler for heating water. The barracks were grouped around the service buildings in clusters called blocks, with eight barracks per block.

Japanese-Americans were transported to Heart Mountain by the trainload from temporary West Coast camps. A train carrying 450-500 people arrived every three or four days. When they were ordered out of their homes, Hosokawa says, the Japanese-Americans had no idea what to expect, where they would go, or for how long. Many wore their Sunday best, as if going on an outing, and they were allowed to take only as much luggage as they could carry. Earlier arrivals met the trains with trucks to transport them to the camp, where they were assigned quarters.

"On August 12, 1942, somewhat bewildered Japanese-American men, women and children began to arrive at the Heart Mountain Relocation Center between Cody and Powell," Richard wrote. "War hysteria and the possibility of sabotage had caused their exodus from the West Coast—although Germans and Italians in America were never subjected to the same treatment on the East Coast. Coming on fairly short notice, many were forced to sell their property at a loss and later received only one-third restitution."

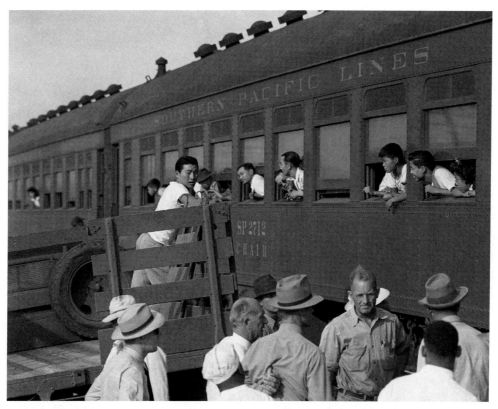

Internees met the train with trucks to transport new arrivals to camp. (1942)

At first, the camp was unfenced, and the inmates were free to wander over the brush-covered flats. But within weeks, Hosokawa says, the Army fenced the campsite with a barbed-wire fence and erected watchtowers with floodlights, manned 24 hours a day by armed U.S. soldiers.

"This provoked intense resentment among the Japanese-Americans who had submitted peacefully to the government's internment order," Hosokawa says. "The watchtowers turned the camps from 'relocation centers' to 'concentration camps' for U.S. citizens."

While photographing camp facilities such as the nine watchtowers, stabilized with guy wires, Richard also took pictures of neatly decorated interiors of the barracks and portraits of families feeling the joy of a brief reunion. Hosokawa points out many families who were imprisoned in the camp had sons and brothers serving in the U.S. Army. When these men in uniform visited their families on leave, they had to have special passes to enter or leave Heart Mountain. When the Army opened its ranks to all Japanese-Americans, many who were living in the camp volunteered for service. A memorial at the campsite lists the names

of 21 Japanese-Americans from Heart Mountain who were killed in action.

Among other portraits of Heart Mountain internees, one finds a little boy with a bright smile seated at a desk. The boy is Hosokawa's son Michael, who was just a toddler when the family was sent to Heart Mountain. Hosokawa built his son's desk out of scrap lumber, the same way the internees built all their furniture—aside from their army-type cots. Hosokawa's son went on to become the assistant dean for curriculum at the University of Missouri School of Medicine. Dr. Michael C. Hosokawa has given lectures on medical education throughout the United States and in China, South Korea, Taiwan and Australia.

Richard's series of Heart Mountain occupies only a thin folder in his negative files, but it includes some of his most important work as a news photographer and most valuable records as a historian. Even as an inexperienced photographer while he was taking these pictures, he revealed not only his sense for news, but also an empathy for his subjects which would shine through all his work, especially his portraiture of the people and personalities of Yellowstone Country.

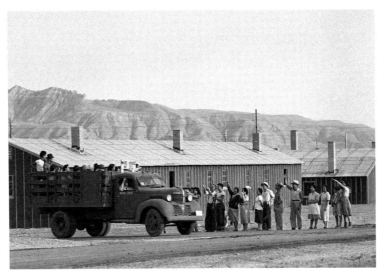
Internees greet the truck carrying the latest arrivals. (1942)

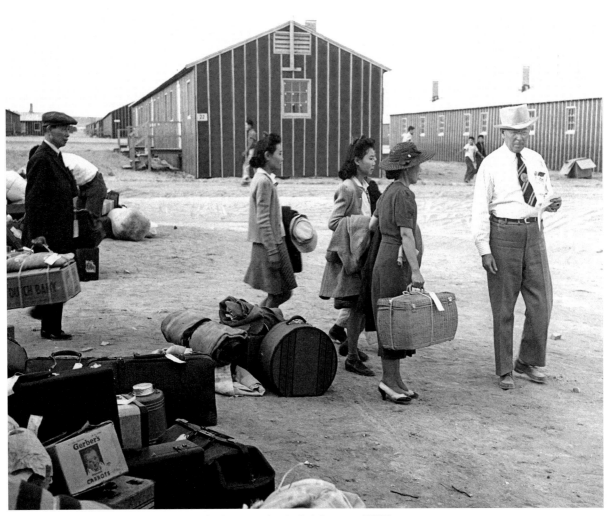
Assistant project Director Guy Robertson helps internees locate their luggage. (1942)

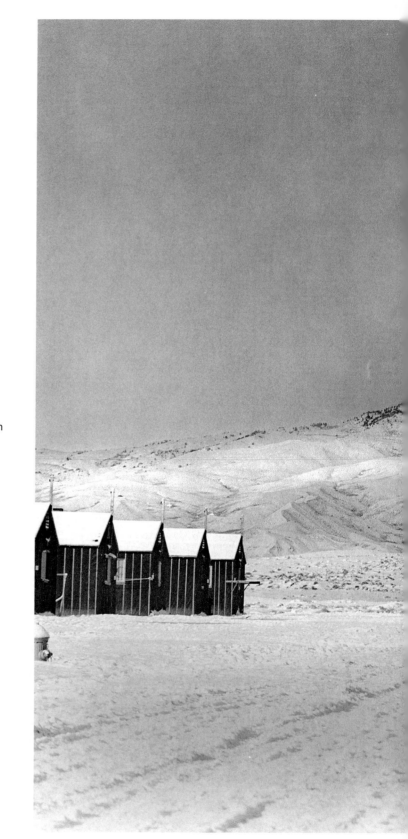

Japanese American women walk through the snow to their barracks, possibly after attending a Sunday church service. (Circa 1942)

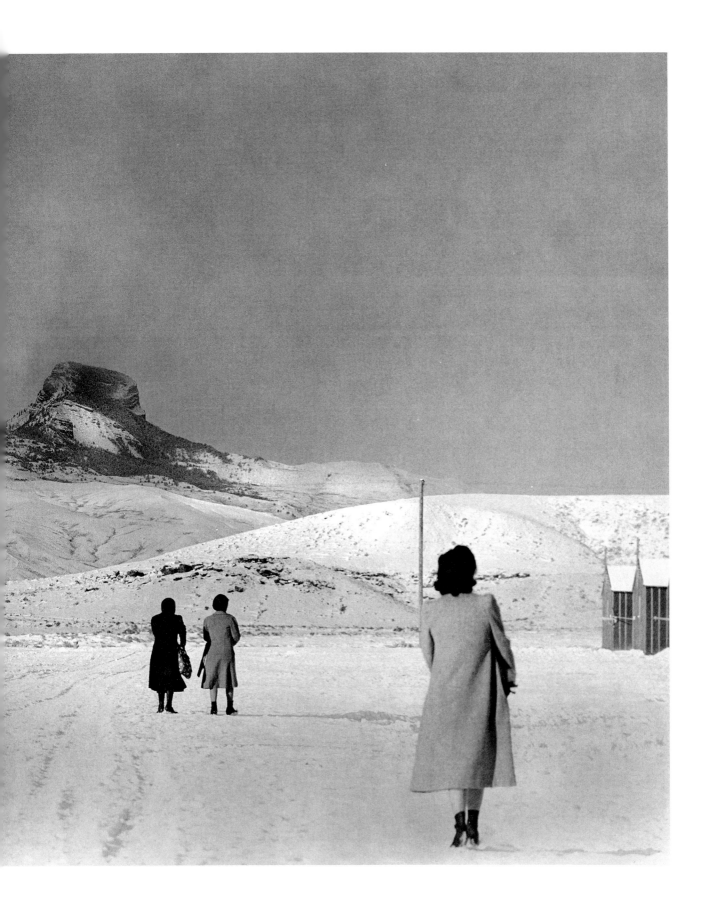

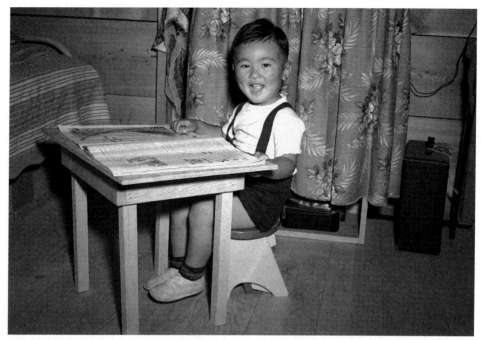

Michael Hosokawa poses at a desk made from scrap lumber. (Circa 1944)

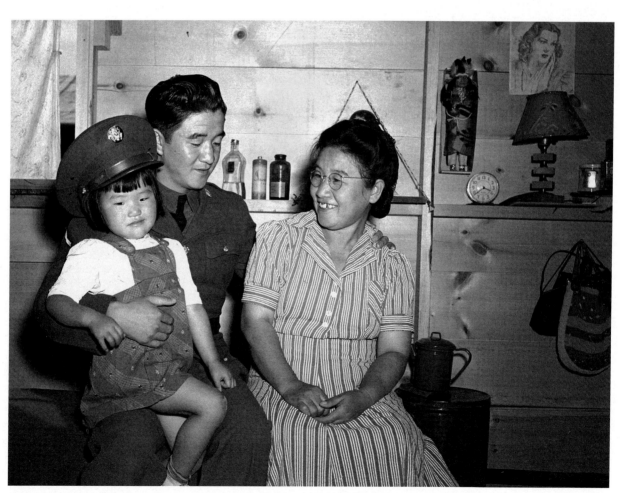

A soldier on military furlough visits his mother and sister in their barracks. Hundreds of Japanese Americans from the camp served alongside American forces during World War II. (Circa 1944)

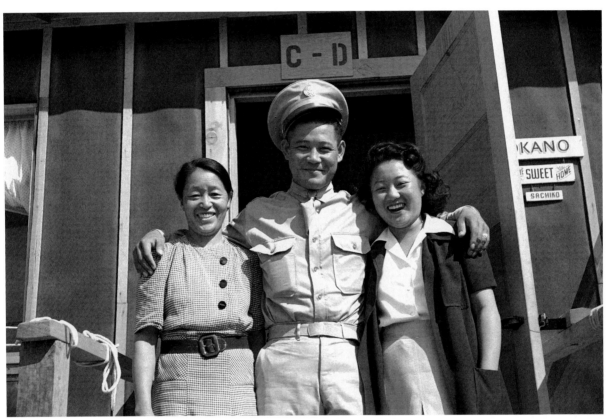

A serviceman on leave reunites with his family at the Heart Mountain Relocation Center. The Okano family dubbed the barracks where they lived "Home Sweet Home." (Circa 1944)

8.
Faces of
Yellowstone Country

I feel most fortunate to have been born here in Cody to a generation of people who were destined to form a bridge to a new era.
—Jack Richard, 1989

Walking through the front door of Jack Richard Photo Studio was like entering a casting room for a production of the people and personalities of Yellowstone Country. It seems like everyone walked through the door at some point for a family portrait, senior class photo or a copy of a

Greg Warnke, 1964

Jack Richard print they had seen in the newspaper. On any given day, one might find Richard's wife, Doris, seated at her desk, holding a print in the light to assess her tinting job. Most likely, Richard was down the hall in the darkroom, peering into his developing tray and watching another face develop through the emulsion. Here was the face of a cowboy from his outdoors way of life, here was an artist he photographed on his newspaper beat, and here was a legendary character he felt he owed it to history to preserve. His life and works merged in his studio in the faces emerging from his developing tray.

Character shines through their faces with such ease because Richard felt at ease with those he

pictured, and they came to feel at ease with him. He felt the joy shining through the face of a wide-eyed girl cuddling her newborn lambs because he grew up in the country the same way she had. He understood the slender grin across the face of a range-toughened cowboy because he knew the breed of humor that ripples through life on the range. He knew so many of them from his newspaper work that he could almost always find the right combination of words to spark their interest and make them comfortable—even propped on a stool in the glare of his floodlights.

Most came willingly to keep their appointments, but others needed prompting. Among the camera shy were several of Yellowstone Country's more legendary characters. As a man who was steeped in the history of his region, and one who was aware of his role as a chronicler of history, Richard was determined to add portraits of these people to his negative files for history students of the future.

"He knew these old-timers were the historic figures in town, and he wanted to photograph them, but a lot of them didn't want to be photographed," Richard's son Bob recalls. It took several years of prompting and coaxing to get Anson Eddy through that door. When he finally showed up, Jack hardly recognized him—all spiffed up in an outfit he'd

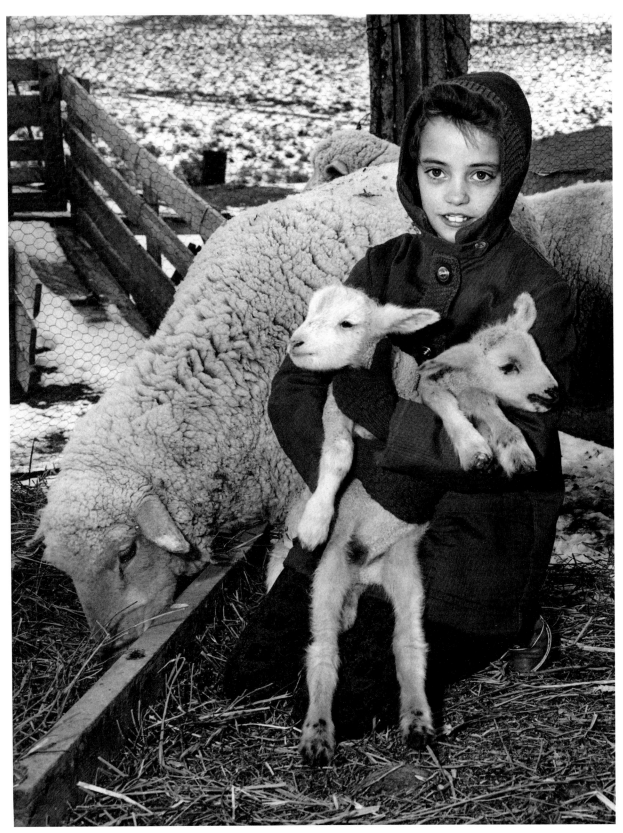

Ten-year-old Marty (Quick) Clark cuddles twin lambs "Abby" and "Tabby." (1959)

Carl Kershner and horse appear at ease as Richard composes a classic cowboy portrait. (1960s)

obviously chosen with some degree of care. Getting his picture taken was a big deal for someone like Eddy who passed his life as a trapper in a cabin deep in the Thorofare—the most rugged country known to man. To make an appearance in town, Eddy would most often hitch a ride with a pack on his back. During the height of winter, he would snowshoe into the seclusion of his backwoods cabin for a month at a time. Ask around for the rest of the Anson Eddy story and you're liable to get seven different versions. Another man coaxed into the studio for historic documentation was Art Holman. This former cowboy and rodeo rider in Buffalo Bill's Wild West show was further notable for his heroic mail stage trips through deep snowdrifts in remote Sunlight Basin.

"I still don't know how Jack got those guys in the studio," Bob notes. "He just had the ability to do that."

Among other memorable portraits, one finds internationally acclaimed artist Harry Jackson posing in 1964 at the age of 40 in front of his 10x21 canvas, "The Range Burial." The painting of the lonely burial of a cowboy had just been hung in the Whitney Gallery of Western Art at the Buffalo Bill Historical Center. Another portrait features Edward T. Grigware while he was painting his masterpiece— the Cody Mural—on the dome of the Cody Chapel of the Church of Jesus Christ of Latter-day Saints.

Further surprises fairly leap out of the box of Richard's portraits—including one that appears odd and whimsical at first glance. It's a portrait of a man dressed in cowboy boots and hat, and zebra-striped beachwear, rocking on a seaside novelty seahorse while taking a picture of a bathing beauty. Beneath this whimsy veneer lays a poignant story. The cameraman on the seahorse is Charles Belden, the best-known photographer to ever plant roots in Yellowstone Country long enough to call it home. From his ranch south of Cody outside the small town of Meeteetse, Belden created masterful

David Winninger practices his roping. (1964)

photos of ranch life that earned him the trademark "the Famous Cowboy Photographer." Belden created his artistic and historic record of ranch life from 1914–40, and Richard got to know him during this period. He befriended him, became a student of his photography and visited him on his Pitchfork Ranch.

After moving to St. Petersburg, Florida, in the early 1940s, Belden adopted a new trademark, "Seahorse Charley," and started photographing bathing beauties as one of his new subjects, according to a 1984 thesis by Vanita Van Fleet Fowden called "Belden: The West of Charles Josiah Belden." While in his 70s, Belden invited Richard to come for a vacation and a relaxing visit during the early 1960s. During Richard's stay at Belden's home, Belden gave him a collection of prized negatives that Richard took home to Cody and eventually donated to the Buffalo Bill Historical Center as part of the Jack Richard Collection. In January 1966, Belden, who had been in declining health, was found in his darkroom with a self-inflicted gunshot wound. He died shortly afterwards at the age of 78, according to Fowden's thesis.

Among other Jack Richard portraits, one finds legendary Park Country Sheriff Frank Blackburn, noted aviator Morris Avery, prominent leaders of the Cody business world and other surprises. Sometimes Jack even got animals to pose for him with apparent ease. It appears he made them feel comfortable, too.

The opening of Richard's studio in 1952 signaled his decision to dedicate more time and attention to what was becoming his full-time profession. At the age of 43, he left the daily grind of newspaper work behind to start a new life as an independent businessman and freelancer. He would still write news and feature stories, work independently as a newspaper photographer and contribute photos to newspapers for many years. But Jack Richard

Donna May and her husband Ernie of the Antlers Ranch above Meeteetse took this beaver into their home and cared for it when it was found abandoned. They called him "Paddy." (1960)

Virginia Hill poses for "Farm-Ranch Day" at the Fred McNeil ranch. (1955)

Photo Studio was now the cornerstone of his life and career, and it would serve him well for more than 40 years.

Peter Wilson says Jack wanted to establish a base of income from a steady business in portraits to give him more freedom to shoot pictures in the great outdoors. He took his portrait photography seriously, teaching himself the basics of the trade and learning the fine points at a portrait school in Chicago. And his name and reputation secured him many contracts for photographic work, including one to produce scenic photos for Wyoming highway maps. While his business solidified, he felt more freedom to foster his network of freelance photography across the region and to national magazines including *National*

Geographic, Life, Time, The Saturday Evening Post, Winchester-Western, National Wildlife and *Sports Afield*.

Over the years, Richard found imaginative ways to improve and expand the studio that started as a Quonset hut tucked away at the back of a yard alongside his home. He designed an efficient floor plan to place a bank of enlargers against the curved wall of the Quonset hut and built a fireproof negative vault the size of a walk-in closet amidst the maze of corridors and add-ons behind the front office. He kept a cot handy for afternoon naps—a tradition dating to his ranch days.

Bill Blake, a Cody portrait photographer who developed a close association with Richard in his

Cody artist Edward Grigware is pictured during the painting of his masterpiece on the dome of the Cody Chapel of the Church of Jesus Christ of Latter-Day Saints. (1951)

later years, still has vivid memories of being guided through the curtain and snaking into Richard's darkroom. Jack had engineered a swiveling tractor seat that could guide along from the wet side of his darkroom to the dry side. One imagines he appeared like a magician floating through his darkroom by the glow of his safelight without leaving his chair. Blake also recalls Jack at work in the studio, flaring his bulbs to flash another print by Cody artist James Bama—and timing the blast with his stopwatch. Blake was fascinated by the old-style perfection Jack achieved this way.

"He showed me how to do it the old way," Blake says, "and that was an art in itself."

Artist Harry Jackson appears with his 10 X 21 foot painting, "The Range Burial." (1964)

Charles Belden, the "Famous Cowboy Photographer," locks his boots in the stirrups of a novelty seahorse as he kids around with his assistant on the beach near his Florida home. After moving to Florida from Meeteetse, Belden photographed "bathing beauties" instead of cowpokes. (Early 1960s)

Anson Eddy is one of the legendary old-timers Richard enticed into his studio. (Early 1960s)

Morris Avery partnered with Mel Christler to operate the Avery and Christler Flying Service in Greybull. (Circa 1960)

Frank Blackburn served as Park County Sheriff for 32 years. When he retired in 1959 to become Justice of the Peace, he was praised for his wisdom, common sense, tact and humor. (1960s)

Art Holman was a cowboy and bronc buster in "Buffalo Bill's Wild West" before he started driving the mail stage to Sunlight Basin. (1960s)

A puppy named "Tiger" gives little Bobby Dimit a fuzzy, wet smooch. Bobby was sitting for his portrait at Jack Richard Studio. (1960s)

Positioned on a cowboy hat, a baby bunny chews a blade of grass. (1951)

These young rabbits were found and adopted by Boy Scouts during a weekend campout. (1951)

Trapper Frank Morris found this orphaned bobcat kitten and two others in their den. (1951)

9.
Still
Lifes

The sun settles quietly in the West,
stretching out the shadows.
—Jack Richard, 1964

By the end of the day when his work was done, Jack Richard lifted one last print off the conveyor belt of his revolving drum dryer, checked the sheen of the gloss and headed for the back door. He locked up the studio, lobbed an old canvas bag in his Blazer and took off down the alley—his camper trailing behind with a rumble.

He was imagining a long weekend and picturing his favorite places: Gibbon Valley with its golden marshes and elk, Island Lake in the Beartooth peaks, and Eagle Creek, where he knew every riffle and pool and almost always got some bites. He could set up his tripod, take that picture he'd been wanting, and still have time to cast a few flies for a supper of pan-fried trout. As the shutter released its soft mechanical click, he hiked into the bright light through the shadowed woods, bamboo rod and net in hand, still thinking some and humming low, because this had been a good life and he was going fishing.

For almost 40 years, Jack kept his camper out back behind his studio so he could be ready to go when he got that urge for a long weekend. Even into his 70s, he commonly motored to the high country to set up camp for more photos. Once in camp, he could catch those sharp rays from the setting sun and rise the next morning for the subtler glow of dawn. Richard's life was all about catching the right light.

Mostly he waited for the right light to enhance elements that Mother Nature and man had already composed for him. Yet sometimes, with a twinkle in his eye, he tinkered and composed elements according to his own design, directing his studio lights on his subject with touches of artistry. Some of these compositions of crosses and folded hands reveal the religious spirit he shared during holidays or times of crisis, while others fairly sparkle with the whimsy of a merry prankster playing tricks on your eyes.

Richard had a ready venue to share these works on front pages of *The Cody Times* and pictorial editions of the *Cody Enterprise*. To produce his front cover for an Easter edition, he meticulously arranged Easter lilies and candles with a Bible and

With net and rod in hand, an angler heads for his favorite fishing hole. (Self-portrait)

A Cody man portrays mountain man John Colter for John Colter Days. (1957)

cast the shadow of a cross against the backdrop. For more lighthearted compositions, he tapped the latest tricks of the newspaper trade, usually with the complicity of the newspaper's pressman. For a 1957 production, he asked a bird hunter to pose for him, lying down in a field for an afternoon nap. He spliced into this image a picture of a "mighty fine specimen" of a Chinese pheasant appearing to poke its head round the corner. The fun continued on page three of the newspaper, where a follow-up photo shows the hunter's dog catching the scent of the bird and doing its best to wake its snoozing master.

Newspaper readers never knew what to expect when Jack coupled his playful sense of humor with his high-spirited imagination. One issue devoted a full page to Jack's picture story of a young rabbit

hunter. The story follows the boy through his day, from piano lessons in the morning, through his adventurous afternoon, to a "closing scene" showing Mom cracking an egg over the skillet for his supper. The punch line of the story, contained in the final cutline on the page, reveals the secret of how this imaginative young character earned the nickname "Hard Luck Howard." Alert readers realized Jack was playing tricks again—like the time he documented, once and for all, the one and only true history of the rare and exotic-smelling Wyoming Jackalope.

Some of his quieter compositions developed from natural moments, like the time he saw his son Bob feeding a baby rabbit with milk from an eyedropper. The boy and the milk bottle, and even the latest edition of his *Cody Times*, were already

Bob Edgar, an archaeologist, explorer, historian and founder of Old Trail Town, hunts the badlands of Oregon Basin with a bow and arrow at the age of 21. (1958)

Vapor trails of jet planes form a halo above "The Scout." (1960)

Richard obtained this view of "Buffalo Bill—The Scout" from the cage of a cherry picker. (1960s)

Richard watched the fleecy clouds for some time before recording this perfect moment on film just before sunset. His photo called "Buttermilk Skies" was judged an award print in the Rocky Mountain Photographers Association's Court of Honor. (1961)

composed at the table. With his camera nearby, Jack had only to adjust the lighting a bit before recording the scene. Other compositions required more effort—like those male pheasants engaged in battle for the female's attention. It took half a day to get that one right—maneuvering those stuffed birds through the crusted snow. Jack's uncle Will, a taxidermist, had been after Jack for weeks to get good pictures of his latest mounts.

"Don't believe anything of what you hear in Wyoming, and only part of what you see," Richard once warned his readers.

Whimsical tones such as these intermingled with tones of spiritual beauty through the timed exposure of Jack Richard's life until the shutter of this life closed at the age of 82 in Cody's West Park Hospital on Sunday evening, April 12, 1992.

Based on many years' experience peering over his father's shoulder in the darkroom, Jack's son

Bob felt he became even more precise and demanding about his work in later years. At the same time, he drew ever closer to the high country where he was raised, moving with his wife Doris to his "retreat" at Logan Creek on his father's retirement homestead. From there, he continued to launch photo expeditions. By that time, he had expanded beyond purely black-and-white photography and was anxious to develop his growing line of photos in the full range of the spectrum. During his 70s, he became especially fond of flowers in the mountain meadows. High in the Beartooth Mountains he took a picture he would later call his proudest achievement. It was a picture of a rare high-mountain orchid. In its intricate petals he saw the details of Mother Nature's plan more clearly. Like his fisherman hiking into the brilliant gold, he saw the colors, too.

The Rev. R. N. Buswell posed for this cover photo on a Cody Enterprise Easter edition. (1959)

To memorialize the assassination of President Kennedy, Richard employed a cross, a newspaper headline, and the hands of Rev. Lester Edgett folded on a Bible opened to a passage from the 33rd Psalm. (November 1963)

Cody pastors and a flower shop loaned Richard the elements for this Easter scene. (1965)

Young Bob Richard feeds a pet rabbit on a "Farm and Ranch" edition of the *Cody Times*. (1950)

Dick Frost set up this chuck wagon display in the yard of the old Buffalo Bill Museum. (1955)

Nostalgic trademarks line the shelves of a general store at South Pass City, Wyoming. (1960s)

Jack Richard posed this mounted pheasant in a field. (1940)

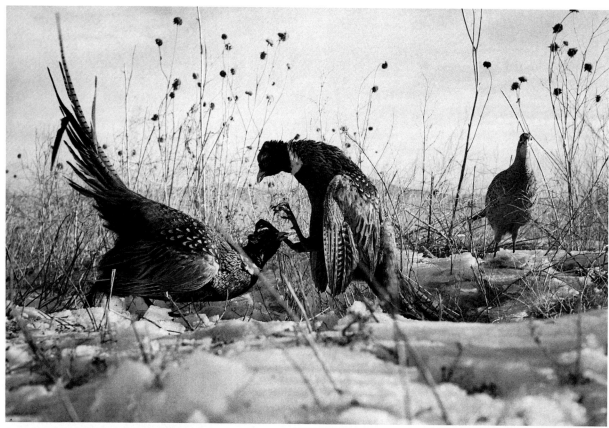

Jack and his uncle Will, a well-known taxidermist, spent half a day arranging these mounts of two cock pheasants fighting while a mounted hen observes the battle. (1940)

THE TRUE HISTORY OF
THE WYOMING JACKALOPE

(Jack Richard wrote this "true history of the Wyoming Jackalope" in the Jan. 31, 1957, Cody Enterprise.)

"Seeing is believing," or, "the camera doesn't lie," are two trite phrases that could apply to our pictures of the rare Jackalope. There's an old saying in our state: "Don't believe anything of what you hear in Wyoming and only part of what you see." However, if you have seen a Jackalope, as some have, late at night when returning from a Lodge meeting, then let your conscience be your guide. Through diligent research, we have compiled the following history of this strange, exotic-smelling creature:

Jackalope

Many years ago, the beaver trappers, Indian fighters and mountain men converged along the banks of the Green River. They had paddled down the thawing rivers or waded through the mountain snows, and they were all primed for a rendezvous. Those who came early extracted from a fire built of sagebrush, buffalo chips and prairie grass, a type of water of faultless clarity but with the disruptive punch of a hydrogen bomb.

History has obscured many of the details, but after a week's diet of firewater and buffalo jerky, those hardy pioneers were of no mind to take warning from the black clouds that boiled up from the north and from the growth of ice crystals along the riverbank.

Those who recall the storm allow they would all have frozen as they lay behind rocks and tall brush if it hadn't been that some strange animals – about the size of jack rabbit but with horns resembling prairie antelope – came out of the wasteland and attacked their sleeping forms with such fury as to rouse them from their stupor and make them huddle together for protection.

Gradually as the men swung back and forth to protect their shins and chin whiskers, heat generated by buckskin rubbing against buckskin brought circulation back to their veins. With savage roars and epithets, the men drove the animals away, melted the snows and returned to their rendezvousing.

This is the first authentic record of these small animals. The fine buck pictured here is part of a herd living in the Natural Corrals north of Cody - the only known remaining herd in the West.

Acknowledgements

This book was made possible by many people who believe in the value of Jack Richard's photography. Bob Richard and Mark Bagne offer sincere thanks to all of you and to anyone we accidentally overlooked.

We're personally grateful for those who were with us all along, gave us a timely boost or made special contributions, especially Bob's wife, Melene Richard; Mark's wife, Laurie Quade; and each of our families. Others who played a key role are Charles and Ursula Kepler, Peter Wilson, Bill Hosokawa, Paul Bagne and Edgar "Bud" Good.

Thanks to Al Simpson, chairman of the board of trustees of the Buffalo Bill Memorial Association, and the entire staff of the Buffalo Bill Historical Center, especially former Executive Director B. Byron Price; Deputy Director for Collections and Education Robert B. Pickering; Associate Director Eugene W. "Wally" Reber; Registrar Elizabeth Holmes and Associate Registrar Ann Marie Donoghue; McCracken Research Library Curator Nathan Bender, Librarian Frances Clymer and staff; Photographer Chris Gimmeson and assistant Sean Campbell; former Buffalo Bill Museum Curator Paul Fees; Director of Communications Thom Huge and staff; Museum Selections Gift Shop Manager Dean Swift; Campaign Associate Suzi Johnson; Preparator Leo Platteter and Publications Coordinator Barbara Colvert.

Special thanks also to Rick Rinehart and Stephen Driver of Roberts Rinehart Publishers; Park County Historical Archives Curator Jeannie Cook and staff; Park County Library/Cody Branch ; Cynthia Rubin, Joe Ratliff, Mike McCue, and the staffs, past and present, of the *Cody Enterprise* and The *Cody Times*.

And thanks to these individuals for helping our book take shape: Trampus Barhaug; Quin Blair; Bill Blake; Roger Bush; Les Cain; Jack Cash; Marty Quick Clark; Bob Edgar; John Elgin; Greg, Kay, Bill and Mack Frost; Ernie and Marge Goppert; Ray Hall; Bruce and Margie Jones; Ron Hill; Louis "Junior" Kousoulos; Brent Larsen; John Lounsbury; Gary Lundvall; Mike May; Greg McCue; Allen McCumber; Jay Moody; Bob and Alice Murphy; Don Nafus; Jim Nielson; Margaret NeVille; Ralph Newell; Bill Oliver; Lucille Patrick; Ella Quick; Dave Reetz; Chip and Geri Richard; Craig Satterlee; Dave Schwarz; Kathy Singer; Frank Smith; John E. "Jack" Stauffer; Dave Sweet; Larry and Maxine Thomas; Lili Turnell; Dewey Vanderhoff; Jack and Pink Way; Bud Webster; and Dave, Lora and Jack Winninger.

Peter Wilson took this picture of Jack and his son Bob on Dead Indian Pass. (Circa 1939)

Archive Numbers:

Following are Buffalo Bill Historical Center archive numbers and additional sources for images in this book, identified by page numbers:

Cover, PN8930028; v, Bob Richard Collection; x, BBHC photo; xiii, bottom, P891472; xiv, PN.89.5000.1; 1, Bob Richard Collection; 2, PN.89.30000; 3, PN.89.30001; 5, PN.89.30002; 6, PN.89.50001.1; 7, top, PN.89.5000.2, bottom, P.89.2506; 8, top, P.89.2700, bottom, P.89.2696; 9, P.89.2698; 10, P.89.2468; 12, PN.89.30003; 13, P.89.2513; 14, P.89.2185; 15, top, P.89.2378, bottom, PN.89.30004; 16, P.89.2482; 18, P.89.2434; 19, top, PN.89.30005, bottom, P.89.2561; 20, PN.89.30006; 21, PN.89.30007; 22, P.89.4266; 23, Bob Richard Collection; 24, PN.89.5002.1; 25, PN.89.30008; 26, P.89.1444.1; 27, PN.89.30009; 28, P.89.1948; 29, PN.89.5003.1; 30, PN.89.5004.1; 32, P.89.1967; 34, P.89.904; 35, P.89.791; 36, P.89.3998; 38, P.89.844; 39, P.89.759; 40, P.89.1772.2; 42, P.89.1805; 43, PN.89.5005.1; 44, P.89.1955; 46, PN.89.30010; 47, PN.89.30011; 48, P.89.1439; 49, PN.89.5006.1; 50, PN.89.30010; 51, P.89.2770; 53, P.89.602; 54, P.89.4100; 55, P.89.1384; 56, P.89.115; 57, PN.89.5007.1; 58, PN.89.30012; 60, P.89.1677; 61, PN.89.30013; 62, P.89.2752; 64, PN.89.30015; 65, P.89.1405; 66, P.89.2901; 67, P.89.2214; 68, P.89.2201; 69, P.89.2603; 70, P.89.2193; 72, PN.89.30016; 73, PN.89.5000.3; 74, P.89.923; 76, top, P.89.216, bottom, P.89.220; 77, P.89.2091; 78, P.89.2036; 79, P.89.4145; 81, P.89.1376; 82, P.89.4167; 83, P.89.1366; 84, top, PN.89.30017, bottom, P.89.1730; 85, P.89.4111; 87, P.89.24; 88, P.89.9; 90, P.89.82; 91, P.89.74; 92, P.89.742; 94, P.89.423; 95, P.89.4169.2; 96, P.89.1016; 97, P.89.1883; 98, P.89.1400; 99, P.89.1002; 100, P.89.1635; 101, P.89.258; 102, PN.89.30018; 103, P.89.121; 105, P.89.5291; 106, P.89.423; 107, top, P.89.710, bottom, P.89.2718; 108, P.89.31.1; 109, top, P.89.706, bottom, P.89.1919; 110, P.89.4004; 111, PN.89.30019; 112, P.89.1425; 113, P.89.1422.3; 114, PN.89.30020; 115, top, PN.89.30021, bottom, P.89.1428; 117, P.89.1430; 118, top, PN.89.30022, bottom, P.89.1418, 119, PN.89.30023; 120, P.89.1018; 121, P.89.1813.2; 122, P.89.1361; 123, P.89.833; 124, P.89.170; 125, P.89.717; 126, P.89.383; 127, P.89.374.2; 128, P.89.4102; 130, PN.89.5009.1; 131, top, P.89.8, bottom, PN.89.5010.1, right, P.89.3945; 133, P.89.718; 134, top, PN.89.30024, bottom, PN.89.30025; 135, P.89.599; 136, P.89.708; 137, P.89.4232; 138, P.89.1537; 139, P.89.1270.2; 140, top, PN.89.30026, bottom, P.89.393.1; 141, P.89.397; 143, P.89.1167; 144, P.89.708; 145, P.89.668; 146, P.89.1986; 147, top, P.89.281.2, bottom, P.89.2118; 148, top, PN.89.5011.1, bottom, PN.89.30027; 148, P.89.1983.1; 150, Bob Richard Collection.